HELPING CHILDREN TO DRAW & PAINT IN EARLY CHILDHOOD

Children and Visual Representation

HELPING CHILDREN TO DRAW & PAINT IN EARLY CHILDHOOD

Children and Visual Representation

JOHN MATTHEWS

SERIES EDITOR TINA BRUCE

Hodder & Stoughton

A MEMBER OF THE HODDER HEADLINE GROUP

British Library Cataloguing in Publication Data

Matthews, John
 Helping Children to Draw and Paint in
 Early Childhood – (0–8 years series)
 I. Title II. Series
 372.52

ISBN 0 340 58911 6

First published 1994

Impression number 10 9 8 7 6 5 4 3 2 1
Year 1999 1998 1997 1996 1995 1994

Typeset by Wearset, Boldon, Tyne and Wear.
Printed in Great Britain for Hodder & Stoughton Educational, a division of Hodder Headline Plc, 338 Euston Road, London NW1 3BH by The Bath Press, Avon

CONTENTS

Series Preface – 0–8 Years: The First Phase of Living

At most times in history and in most parts of the world, the first eight years of life have been seen as the first phase of living. Ideally, during this period, children learn who they are; about those who are significant to them; and how their world is. They learn to take part, and how to contribute creatively, imaginatively, sensitively and reflectively.

Children learn through and with the people they love and the people who care for them. They learn through being physically active, through real, direct experiences, and through learning how to make and use symbolic systems, such as play, language and representation. Whether children are at home, in nursery schools, classes, family centres, day nurseries, or playgroups, workplace nurseries, primary schools or whatever, they need informed adults who can help them. The series will help those who work with young children, in whatever capacity, to be as informed as possible about this first phase of living.

From the age of eight years all the developing and learning can be consolidated, hopefully in ways which build on what has gone before.

In this series, different books emphasise different aspects of the first phase of living. *Getting to Know You* and *Learning to be Strong* give high status to adults (parents and early-childhood specialists of all kinds) who love and work with children. *Getting to Know You*, by Lynne Bartholomew and Tina Bruce focuses on the importance of adults in the lives of children. Observing children in spontaneous situations at Redford House Nursery (a workplace nursery) and in a variety of other settings, the book emulates the spirit of Susan Isaacs. This means using theory to interpret observations and recording the progress of children as they are supported and extended in their development and learning. The book is full of examples of good practice in record-keeping. Unless we know and understand our children, unless we act effectively on what we know, we cannot help them very much.

Learning to be Strong, by Margy Whalley, helps us to see how important it is that all the adults living or working with children act as a team. This is undoubtedly one of the most important kinds of partnership that human beings ever make. When adults come together and use their energy in an orchestrated way on behalf of the child, then quality and excellent progress are seen. Pen Green Centre for Under-fives and Families is the story of the

development of a kind of partnership which Margaret McMillan would have admired. Beacons of excellence continue to shine and illuminate practice through the ages, transcending the passing of time.

Just as the first two books emphasise the importance of the adult helping the child, the next two focus *on* the child, and on learning processes of which adults need to be aware. In *Helping Children to Draw and Paint in Early Childhood*, John Matthews helps us to focus on one of the ways in which children learn to use symbolic systems and looks at how children keep hold of the experiences they have through the process of representation. Children's drawings and paintings are looked at in a way which goes beyond the superficial, and help us to understand details. This means the adult can help the child better. Doing this is a complex process, but the book suggests ways which are easy to understand and is full of real examples.

Later in the series, Mollie Davis looks at *Movement* (which includes dance) and its major contributions to development and learning. She focuses on actions, as well as representations, play and language, demonstrating that movement is truly one of the basics. She gives many practical examples to help those working with children enjoy movement with confidence, bringing together actions, feelings, thoughts and relationships.

Other books in the series will underline the importance of adults working together to become informed in order to help children develop and learn.

Clinging to dogma, 'I believe children need . . .' or saying 'What was good enough for me . . .' is not good enough. Children deserve better than that. The pursuit of excellence means being informed. This series will help adults increase their knowledge and understanding of the first eight years of life, and to act in the light of this for the good of children.

TINA BRUCE

ACKNOWLEDGMENTS

I would like to thank the following people for sharing their ideas with me: Tina Bruce; Chris Athey; Vic Kelly; Geva Blenkin; Alan Costall; Elsbeth Court; John Willats; Francis Pratt; Paul Light; Dennis Atkinson; Nick McAdoo and Claire Golomb. I also learned a great deal from the late Nancy Smith. Finally, thanks to Linda Matthews, Benjamin, Joel and Hannah, and all the other children who have helped to educate me.

To Linda
'Everyone is in the best seat'
John Cage

INTRODUCTION

This book shows how young children's drawings and paintings begin and develop and why their early visual representation and expressions are important – namely because when they represent anything (using a mark, a shape, an action or an object) *they make something stand for something else*, and *through expression* (in speech, action or images) *they show emotion*.

In this book, *drawing* is defined as a predominantly linear way of defining shapes and events. Often, but not necessarily, drawing actions leave a trail or visible line. *Painting* uses coloured pigment to describe areas in patches of surface colour. In practice, however, what we think of as drawing and painting naturally overlap.

Although drawings and paintings represent the main focus of the book, I feel it is important to show how these link with the growth of representation as a whole. I do not favour the view that young children only scribble until they can produce visually realistic pictures. This makes the mistake of comparing children's drawings with one particular type of picture made by artists and other adults.

Even though I am an artist who loves art, and believes that children are sometimes truly engaged at an aesthetic level (Matthews, 1992) I have mostly avoided using the word 'art'. This is partly because children use a wide variety of materials, actions and objects for representation and expression. Indeed, some young children seem to be able to turn anything into visual media in ways which are unequalled in post-modern art. Children's intentions, and the understandings they form when they use different media, are not captured by most adult definitions of art. Children engage in activities and use materials which people do not normally see as art. At first glance, some of what they do looks fairly trivial – twirling, running, jumping up and down, shouting, singing. With some important exceptions (Wolf and Fucigna, 1983; Athey, 1990; Davies, 1994) most researchers regard these as irrelevant to children's drawing and painting (and people generally do not see these as important to a child's education). However, actions and movement are very important to the growth of thinking and feeling, as this book will show.

My own children, Benjamin, Joel and Hannah, helped me to write this book. I studied Ben and Joel until they were seventeen and nineteen, and Hannah, now twelve years will, I hope, allow me to continue sharing her drawings and paintings with her. They have been privileged in the sense of having access to art materials and parents who are skilled and interested in drawing and

painting as well as knowledgeable about child development. Linda and I helped the children and discussed their drawings and paintings with them.

Ben is now an accomplished draughtsperson, and his talent was apparent in his drawings from the age of two-and-a-half years, if not before. He is an interesting blend of typical and atypical development, and we shall look at his progress in drawings in detail. He, in particular, helps us to see how we can help other children as they draw and paint.

METHODS OF OBSERVATION

Observations of Joel and Ben: from birth to seventeen and nineteen respectively. Observation of Hannah: from birth to twelve years and ongoing. My methods of recording were naturalistic. I recorded the words and actions which accompanied the drawings and other processes. This was important, because children's meaning is not always apparent in their finished work. I made records of about 600,000 words per child in journals; recorded about 500 hours of audiotape recordings; and made 300 hours of video and film recordings. Because I was interested in children's spontaneous development I did not use experiments, but designed ways of recording everyday settings which did not disrupt the children's activities and allowed them to be completely unselfconscious. The children became so used to the recording equipment that they sometimes used it themselves, producing some valuable data! Slow-motion techniques and frame-by-frame analysis of film and video recordings were used to analyse drawing actions, and also revealed the children's intentions whilst drawing and painting as well as the way children relate to each other and adults while they draw and paint. They provided a valuable insight into how adults might help children in these activities.

I also took about 5000 photographs of children's drawing, painting and play. This links with the suggested ways of making records and assessing children's progress advocated by Lynne Bartholomew and Tina Bruce in their book *Getting to Know You* (1993) also in this series. The observations are in the spirit of the early parent–baby biographies, and the later work of the child study movement and of Isaacs, Piaget, and Athey.

Added to this I studied forty nursery children (aged between three and four years) over a two-year period in a class in a London state school. The observations were recorded in note form and were supplemented by forty hours of video-recorded drawing and painting sessions. Whilst not as detailed or extensive as the studies of Benjamin, Joel and Hannah, it was interesting to see

the way this group of children, diverse in ethnic, class, and gender terms, and attending school in an impoverished area of London, still reflected the same things about the way children begin to draw and paint.

1 PAINTING IN ACTION

Ben aged two, stands at a low table on which there is a sheet of paper and two pots of paint, one green and one blue. In each pot stands a paint brush. First of all, Ben picks up the blue brush with his right hand and paints with it, using a vigorous fanning or arcing action from side to side across the surface of the paper. This action creates an elongated, curved blue patch, like an arc of a large circle. His whole body seems involved in this energetic painting action.

The brush never leaves the surface of the paper but every now and then Ben abruptly changes his sideways fanning action to a pushing and pulling movement, to and from his chest. The paint brush therefore moves in two opposing directions, from side to side, creating the blue arc, and this new, back and forth movement, crossing it at approximately ninety degrees, giving it a jagged contour.

Ben then puts this blue brush back in a pot and picks up the green brush. As he carries it over the painting, paint drips from it, leaving a trail of green spots across both the table and the painting. He notices this and immediately shakes the brush above the painting, making more green spots fall onto the white paper. In the meantime, Linda, his mother, has prepared a pot of red paint for him and has placed it with a brush inside on the table next to the other two pots. Picking up this red brush he makes further arcing movements over the blue patch. The red mixes with the blue to make a brownish colour. He momentarily stops painting, and points with his left index finger to a particular part of the painting. The focus of his attention appears to be a section of the painted patch's irregular edge which his paintbrush has just produced. 'There's a car there,' he says (see Figure 1.1).

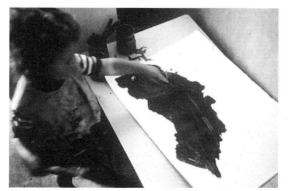

Figure 1.1 'There's a car there,' by Ben aged two

Ben stops only for a moment, however, returning to his painting to make variations and combinations of the actions he has already produced. Arcing movements now flow into zig-zag movements. The brush remains in contact with the paper, even when, for a moment, he looks up at me and smiles. Quickly turning back to his painting Ben suddenly makes a quite different painting action. His brush describes a series of continuous, clockwise rotational movements. The first revolution runs right through the patch to which he had just referred as the 'car'. Each succeeding rotation almost coincides with the previous one. As he makes this continuous rotation he says, 'It's going round the corner . . . it's going round the corner . . . it's gone now.' (See Figure 1.2). He

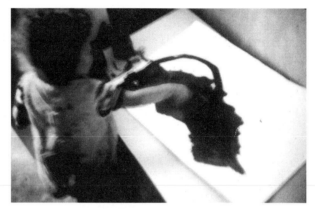

Figure 1.2 'It's going round the corner,' by Ben aged two

then dips the brush into the red pot again, and aims it into the roughly circular closed shape he has made. He repeatedly plonks the brush down with a quick, rhythmical stabbing motion. This makes red blobs appear in and around the centre of the closed shape (see Figure 1.3).

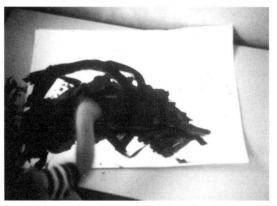

Figure 1.3 Ben makes marks inside a closed shape

Ben then vigorously smears these red blobs with the same brush, using that same horizontal arcing motion again. Very soon, the rotational shape and the small sector of white paper, which up to now remained within it, are obliterated under this energetic side-to-side movement of the brush.

SOME QUESTIONS

The above painting episode is typical of a kind practised by many two- to four-year-olds (Matthews, 1983; 1984; 1988; 1990). What does it mean? Is it a series of haphazard, random actions, without meaning? Is it mindless 'scribbling'? Many people would say that Ben is just messing about with paint. They might feel that this is neither an organised abstract design nor a drawing. Drawing, they might argue, is about making recognisable pictures, or accurate 'representations' of objects, scenes and people. This child surely cannot be representing anything, since his painting is not a 'picture' of anything which we can recognise.

Even seeing Ben in the process of painting and hearing what he says about it would still fail to impress many people that anything significant was happening. They might agree that Ben enjoys this impulsive activity, but argue that it is just the clumsy beginnings of a long apprenticeship towards correct drawing and painting. True, they might say, his actions seem intense, but surely much of his body movement is completely irrelevant to what drawing and painting are really about?

It is also true to say that he talks excitedly about the painting but what is he talking about? Surely the only accurate term he uses is 'round' and we might expect young children to name a few shapes which accidently occur in their paintings. How do his other words correspond to his painting? He mentions a car, but where is the car? Surely his words are inappropriate and only have meaning for him?

This, after all, is the message given to us by the vast majority of books about the 'stages' of children's drawing development. Some writers on children's art acknowledge early 'mark-making' as having emotional importance, or importance in terms of the coordination of body movements and being able to use a paintbrush or pencil, but very few of them consider it to be the beginnings of *visual representation* – of drawing and painting. Usually it is called the 'scribbling' stage. Some researchers of children's art acknowledge that scribbling is important for its emotional and aesthetic aspects, but consider its real importance to be the way children notice shapes they accidentally produce. Kellogg (1969), for example, believes the child, over a period of two or three

years, puts together a vocabulary of shapes out of random mark-making. In other words Ben stumbles upon the 'round' shape and uses this and others accidently stumbled upon, like 'building blocks' put together to make designs and pictures of various kinds.

Some psychologists look at children's drawings and paintings to see how visually realistic they are, which means that children and their drawings are thought to be full of 'deficits'. They write about what is wrong with the ways children make drawings and paintings, and think of drawing development as the 'stages' through which children must pass before they are able to produce 'visually realistic' pictures (Piaget and Inhelder, 1956; and Lowenfeld and Brittain, 1970). Many people think the beginnings of drawing are disordered scribbling, and often the later stages fare only a little better with some writers. Although the recognisable pictures children gradually make are sometimes thought charming, these are also considered strange, full of errors, and are measured against a sort of checklist to see how well they conform to the idea of 'accurate representation'.

These attitudes are often biased towards a restrictively Western European approach to representation originating from the Italian Renaissance. Yet such prejudices about representation are implicit in many accounts of children's drawing and influence the way we provide for the child to draw and paint. Although the terms 'visually realistic', 'accurate representation' and 'stages' trip off many a researcher's tongue, they are notoriously difficult to define and study. At times the way we look at children's drawings and paintings conceals, rather than reveals, the meaning of painting episodes like Ben's. Jerome Bruner (1990) has commented that some kinds of research simply go round and round in circles, merely supporting the assumptions they are supposed to investigate. This happens when we approach children's drawing and painting by emphasising how near to 'visual reality' they are.

I believe that it is more useful to consider the possibility that the mark-making of babyhood is not random, haphazard 'scribbling', but is loaded with representational and expressive meanings, purposes and understandings right from the start.

The way we understand and provide for children to draw and paint also needs to be re-thought. This does not just apply to art education. Children, as they begin to draw and paint, make an intellectual journey which has musical, linguistic, logical and mathematical as well as aesthetic aspects. All of these are endangered if we do not understand the development of drawing. The clichés about children's drawing, painting, and construction are true: they do contribute to the development of children's thinking and feeling. The problem

has been that, as we shall see, with some notable exceptions (Smith, 1983; Wolf and Fucigna, 1983; and Athey, 1990), few people have been able to say what this contribution actually is.

VISUAL REPRESENTATION AND EXPRESSION

Most people would accept that early mark-making is one aspect of a baby learning the skills of handling and using materials. We have to decide whether we are justified in claiming that this is also the beginnings of visual representation and expression. Wolf and Fucigna (1983) suggest this is likely, given what we now know about other aspects of development. For example, recent research strongly suggests that right from birth, the baby develops a range of communicative and representational possibilities in actions and vocalisation.

- We know that newborn babies seem able to take part in shared acts of meaning with caregivers (Stern, 1977; and Trevarthen, 1980).

- They also seem to enter the world equipped with a simple understanding about events and objects.

- Their mastery of objects seems to emerge from meaningful relationships with people, especially the first caregiver (Trevarthen, 1975). We shall return to this later.

Drawing and language

Language acquisition is often seen as a continuous process which has meaning and organisation all the way through. The work of Noam Chomsky (1966) shows that, even though young children's early speech might seem strange, it is the result of children actively generating language *rules* which change as they mature. We will see later the important analogy here to drawing development. Chomsky sees the process of language acquisition as technically creative. Children make sentences which they could not have copied from older speakers. Later, we will see how a similar situation pertains to drawing development.

Scribbling and babbling

How then are we to understand what Ben is doing as he paints? It might be that the rhythm, intonation and communication patterns in babbling, along with the

individual sounds, are carried over into the first true sentences (de Villiers and de Villiers, 1979). A similar relationship might exist between 'scribbling' and the first pictures. Is Ben 'babbling' with paint? He is obviously very involved in the painting, and his whole manner suggests a commitment which would not be conveyed by mindless scribbling. What he is doing seems to be emotional. Perhaps it reflects or conveys his mood. It may help create a mood, or at least intensify an existing one.

He seems to bring some understanding to these art materials, and it is clear that he already knows a great deal about paint. He knows something about paint pots and brushes. He knows how to transport a paint-laden brush from the paint containers to the painting surface. He knows to reload the brush at intervals. Some kinds of knowledge, however, have been acquired in situations common to many children: investigating and playing with food and drink; studying the behaviour of water at bath-time. Ben knows a significant amount about contained liquids, and already seems to know about the confines and uses of the paper. He restricts most of his mark-making to this sheet. Arranging one's attention and actions towards a blank sheet of paper in readiness for the act of painting might be taken for granted by an adult. Yet even a blank sheet of paper is a product of a theory about space and representation developed over many years by a society. Before brush has been set to paper Ben, in his attitude and stance, is doing something just as intelligent as using painting tools. This means that he has already acquired some insights into a particular mode of expression and representation. There is nothing extraordinary about Ben in this regard. Many children aged between two and three years will be introducing themselves to, or being introduced to, painting, writing and drawing media. It does suggest, however, that the way in which children discover, or are introduced to, these media is important and affects their development.

Ben also has great command over a repertoire of actions which can be made with brush, paint and paper. These actions are organised and coordinated with his other knowledge of container and contained paint, so that he is able to respond to the behaviour of this liquid when it is set free by spillage or a brush.

Horizontal arc

There are three basic mark-making movements which produce three basic marks (see Figures 1.4, 1.5 and 1.6). Ben's first mark-making gesture in this painting episode is one in which the brush is swung or fanned from left to right, with the painting arm almost, but not quite, at fullest reach, with much of

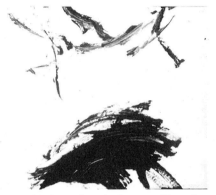

Figure 1.4 Horizontal arc (at bottom of figure)

Figure 1.5 Push-pull

Figure 1.6 A vertical arc creates dots

the movement coming from the shoulders and the hips. This gesture describes an arcing shape; a patch of blue pigment which records a natural swinging of the arm to and fro from the shoulder. It makes visible a normally invisible vector of body movement. This mark-making gesture has emerged from even earlier infancy. I have called it the *horizontal arc* (Matthews, 1983; 1984; 1988; 1990) and its evolution will be described in the next chapter. At this point it might be argued that this is surely a completely physical action, not necessarily indicative of intelligence. Ben even looked up at me, for a moment whilst painting. Is this not the kind of painting action one could make with one's eyes closed?

However, research has shown that this explanation is not justified. It is not just the movement which is important to children in their early drawings. In experiments, children quickly abandoned 'dummy' pens which failed to leave a mark (Gibson and Yonas, 1968; and Berefelt, 1987). When young children paint or draw, they do occasionally look elsewhere and rely momentarily on

information from special sensors in their joints (proprioceptive information) which tells them about the positions of their limbs. However, careful observation shows that they quickly return and look at the drawing to make sure the marking tool is still on course. Sometimes, having regained visual contact, children produce a little burst of speed (Matthews, 1992).

THE IMPORTANCE OF OTHER PEOPLE

Young children look away from their activities in order to look at those very special objects, people. They do this to check their whereabouts and to gauge, engage or maintain the level of interest of these onlookers. Sometimes the pace and organisation of the painting is influenced by subtle responses from the adult. When, for example, Ben looks back from me to the painting, his sudden production of a very different drawing action – an elliptical motion of the brush – may be part of a response to my interest. This is part of the social and interpersonal context in which children make meaning as they draw. The development of children's drawing and painting (or any intellectual or physical skill) does not come about completely on its own. The attitude of the people around the child has a profound effect. The overall direction of the child's developmental journey, and each twist and turn from moment to moment, is influenced by the responses of surrounding people and by society at large. This is a crucially important point, and one over which there is much confusion.

An opposing, and I believe mistaken, idea about children's visual representation is that development in the child's use of visual media happens naturally without any kind of assistance from other people. In fact, some pioneers of child art (for example, Franz Cizek and Rhoda Kellogg) seemed to think that adult influence was actually damaging to the child's creativity, and was to be avoided. It is certainly true that some kinds of adult influence do damage children's development in representation and expression (Bruce, 1991), but as we shall see, the right kind of support and interaction from adults is necessary if we want children's drawing, painting and construction to really flourish (Athey, 1990).

There are people who think that children neither initiate any learning by themselves nor play any significant role in the learning process. According to this view, children are basically empty vessels and the task of education is to 'fill' them with knowledge. Sometimes this idea is blurred with another, that learning comes about by children simply copying adult examples. For arguments mentioned above in relation to Chomsky's work, and for other

reasons given later on in the book, it seems unlikely that copying can explain the developmental sequence through which children's drawing passes. When curriculum designers have these ideas it can be very destructive to children's learning, especially where education is planned only in terms of sets of knowledge and skills to be transmitted to children. This undermines children's internally driven learning processes. Recent so-called educational reforms in the UK are not guided by a knowledge of development but in terms of programmes of instruction based upon assumptions about what constitutes the discipline or subject (Kelly, 1990). Though thinly disguised in dubious developmental 'stages', the English National Curriculum in Art falls into this category (Matthews, 1993).

We shall return to the social context for development throughout the book, but suffice it to say at this point that we are indeed looking at a naturally unfolding sequence of development, which is universal, and which is initiated and driven from within the child. People have a special role to play in providing the kinds of experiences which will encourage and promote this development. As Athey (1990) has described, development is to do with an interaction between what is unfolding within the child and what is available within the environment.

Chance plays a part in this, but it is far from being a random process, for the child is constantly, actively, purposely seeking out those particular experiences which will promote growth. This happens in different ways and at different levels: at a large scale or 'macro' level in which the child makes choices about which objects to investigate and which events to participate in; and at a small scale, or 'micro' level, in which rapid decisions are made about actions performed upon materials. We can see this micro level in the way Ben varies the tempo and direction of his painting actions. Video recordings show that when young children use paint, their movements are not merely mechanical in the muscles and joints, they look at what they do, and can vary what they do intentionally.

Painting actions – varying the tempo and direction

Ben varies his arcing movement by flexing his elbow and he shortens the length of this arc occasionally, to fill in blank areas he has noticed. When he sees such an area, his posture changes; he hunches over the painting, intently concentrating on these new targets. He also re-locates the starting point of the

arc; re-targeting the brush at this position. None of this behaviour seems merely mechanical. On the contrary, the variations he makes suggest rapid and complex decision making. He selects areas for painting. In other words, he already knows something about two-dimensional area and the brushwork needed to fill it.

Push-pull

His horizontal arcing to and fro of the brush is occasionally altered to a push-pulling action, creating an oscillating zig-zagging line. The beginnings of this *push-pull* gesture (Matthews, 1983; 1984; 1988; 1990) will be studied in the next chapter. One effect of the push-pull is to disrupt the boundary of the curved shape. It becomes a more jagged, irregular contour. It produces ragged boundaries of paintwork in which shapes are created. Children notice these shapes and are attracted to them. Ben's push-pull action produces a small patch of colour which sticks out from the boundary of the blue arc. This shape might not seem important, yet for Ben it is. After he has made this little shape he stops painting, looks at it and suddenly points at it with his left index finger saying, 'There's a car there'.

DYNAMIC SCHEMAS – ACTION SCHEMAS

Jean Piaget (1951) describes schemas as repeatable behaviour and action which the child uses in many different situations (Athey, 1990, p. 35). By using the same action on a range of different objects, the child receives valuable information about the object and how the movement has affected the object. Ben uses a grasping schema on long objects such as spoons. He adapts the way he uses the grasping schema in holding another long object, a brush.

These dynamic, action schemas are internalised and become images of things, or *figurative* schemas. Ben holds the brush (a *dynamic action* schema) and he holds an internal picture of a brush (a *figurative* schema). Different schemas are gradually combined to make more complex sequences of action. For example, Ben combines his horizontal arcing schema with his push-pulling schema. This combination produces the patch he says is a 'car'.

REPRESENTING SHAPE AND MOVEMENT

What does Ben mean by this? He seems to be using the shape of the patch to stand for the shape of a car. The representation suggests the shape of an object. It is a *configurative representation*. A moment later, he makes a very different kind

of movement – the *continuous rotation* of the brush (Athey, 1990; and Matthews, 1983; 1984; 1988). This is a very important drawing action for the child, and we will see how it develops later in the book. Ben also makes a different kind of representation, an *action representation*.

Ben uses the rotational, round-and-round movement of the brush to represent, not the car's *shape*, but its *movement* in time and space. Whilst the brush is in motion, Ben says, 'It's going round the corner . . . It's going round the corner.' He uses the brush's 'trace-making effects' (Michotte, 1963, p. 289) to show the passage of movement of the car. He also uses other kinds of changes going on in the paint. For example, when the paint line loses contrast against the blue patch and disappears, he says, 'It's gone now.'

The comings and goings of objects, the different ways they come in and out of sight, are very important to the young child. We will see this idea influencing painting and drawing in different ways and at different levels during babyhood and childhood. With the exception of Wolf and Fucigna (1983) and Athey (1990) this type of representation seems to have been unnoticed by the majority of researchers. The tendency has been to think of 'representation' as synonymous with 'picturing'. Consequently, this use of art materials is not considered representational at all. Action representation has rarely been described and its relationship to the development of drawing is yet to be fully understood. This intense participation with painting actions may have strong influences on later representation. There are many questions to be asked about action representations. In Ben's painting, for example, where precisely is the representation taking place? Is it in the paint trails; the brush's movements, or in his moving arm? Equally, it is difficult to say exactly what the lines and shapes stand for. Nevertheless, we can be sure he is forming some profound understandings in his 'collaboration' (to use artist Robert Rauschenberg's term) with the unfolding event of painting.

Some of the things he understands are to do with shape, location and movement. We will see in the next chapter that babies are interested in these right from birth, so it is perhaps not surprising that we find these concerns represented in painting, drawing and three-dimensional construction. Children use all sorts of media to establish the reasons why things happen, and to link shape, location and movement. It may be no accident that Ben's first revolution of the brush runs perfectly through the centre of the patch which represents the 'car'. He may be interested in the idea that the same object which was stationary and which occupied a single position in space, can move. We will see in later chapters how painting and drawing are perfectly suited for a child to investigate what does and does not move, and how.

Closed shape

The rotational movement of the brush results in a roughly circular *closed shape*. Ben loads a brush with red paint and stabs it at approximate right-angles to the paper's surface within the boundary of the closed shape. This results in blobs enclosed within the closed shape. The closed shape is an important visual structure in drawing development. With this form, Ben, like most other children, will use it to represent the spatial relationship *inside and outside*. We can see the beginnings of this here. The discovery and use of the closed shape will be described in Chapter 4.

Painting as a patterned dance in space and time

Ben's painting is like those of many young children. It is a rhythmical, patterned dance or play with paint and body actions in space and time. There are:

- different possible starting points;

- a network of intricately timed entrances and exits;

- interpenetrating plots and sub-plots, and a variety of stopping points.

When Ben finally obliterates the closed shape and its red nuclei under a vigorous arcing of the brush, this is one of many possible 'curtain closing' acts.

PLAY

Play makes all this possible. Play is implicated in the development of all forms of representation (Bruce, 1991). During the period when this painting was produced, Ben moved a handheld toy car around the home, often talking softly to himself as he went. He often referred to the direction of the car, including going 'up', 'over' and 'down' obstacles; going 'through' tubular forms, and going 'round'. When he refers to 'a car . . . going round the corner' whilst painting, he has 'transported' (to use Dennie Wolf's 1983 term) a familiar scenario from his play with toy cars over into the activity of painting. Now, a handheld brush replaces the handheld toy car, as if the brush has become the toy. What is the significance of this?

Play is difficult to define but indispensable to learning. When children struggle to master actions, objects and skills, or when they try to understand

something new, as when Ben learned to grasp a brush, put it in a pot and lift it out without spilling the paint, children adapt their actions and their thinking to the demands of these tasks and objects. Piaget called this process *accommodation*. This is not play.

Play allows us a completely different attitude. When children play they can temporarily free their actions from the restrictions imposed upon them by the demands of the situation. They can change the situation to fit their own existing behaviour. Piaget called this *assimilation*. Ben lifts the loaded brush and droplets of paint splatter from it. At this point, he does not attempt to correct the action. On the contrary, he extends it on purpose by shaking the brush to cause more drops to splatter on the paper. Of course, he is still using skills and understandings he has already developed, such as his knowledge about inertial forces which enables him to splatter droplets from the shaken brush. However, these techniques are not used with a fixed end in mind, but are of interest in themselves as the currency of free-play. This is also true of the unpredictable events these techniques set in train.

Ben is completely involved in what he is doing with the paint on the paper. Whatever happens he will incorporate it into the painting. When he lifts a brush, moves it to the surface, or trails it on the surface, different things happen. He has to make rapid-fire decisions from moment to moment. His choice of one course rather than another is influenced by his schemas which act like plans or blueprints for his actions. These cause him to respond in one way rather than another. Piaget thought that different schemas became coordinated and gradually internalised into the child's brain to become thoughts and images. This might be happening to Ben.

ACCIDENT OR INTENTION?

Ben's act of painting is a dynamic balance between what he wants to do and how it turns out. What happens might look accidental but I believe it is likely that the accidental has been overemphasised in many studies of how children draw and paint. One influential account of drawing, which still affects people's thinking, comes from the work of two men, Piaget (1951) and Luquet (Luquet, 1927). Luquet was a great pioneer of children's drawing and had some extraordinarily sensitive insights about it. Piaget used Luquet's ideas (unfortunately perhaps) in his own theory. The Piaget/Luquet model of drawing development suggests that children pass through distinct stages starting from 'scribbling'.

- They begin with Fortuitous Realism, in which they make random marks and continue to do so for a couple of years or more, until they notice the similarity between a shape they have produced accidently, and a shape in the world.

- They then learn to repeat and control these shapes which were initially the result of accident.

- Following this, they are supposed to enter a stage of Intellectual Realism in which they draw what they *know* rather than what they *see*.

- Much later, at around age seven, they are supposed to reach the stage of Visual Realism in which this situation is reversed and they draw what they see rather than what they know.

There are aspects of very young children's painting which seem to fit into the Piaget/Luquet model. For instance, when Ben makes a patch which he then names 'a car', surely this is a case of him naming a 'fortuitously realistic' mark. By chance, the child stumbles on a resemblance, but this ignores the fact that the child is exploiting an entire range of possibilities. Whilst it is true that at the beginning of drawing and painting, children are not always in control of skidding brushes and splattering paint, the idea that accident is the main mechanism of development is simply not true. See, for example, Figure 1.7

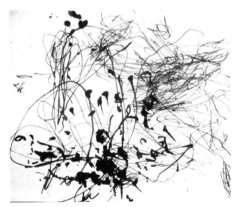

Figure 1.7 A so-called 'scribble' by Ben aged two years and four months

which shows a so-called 'scribble' by Ben at age two years and four months, made from a combination of basic mark-making movements. Already he is giving such drawings representational and expressive values. Early painting

and drawing are like a dialogue between what the child wants to do and what appears on the paper. The child takes advantage of different kinds of opportunities which arise out of this interaction. The child notices, not only chance *shapes* but chance *events* too. These suggest to the child, not accidental likenesses, but new actions which might be made.

By supporting children's painting and drawing we are empowering them; giving them some way of controlling their lives. Ben did this when gaining mastery of the painting materials, but also at the representational level. He represented and explored his feelings about possessing power. He created a car on the paper, using paint. It is important to appreciate that the 'car going round the corner' would have a driver who could possibly be Ben. Ben may be using this representational act, as other children would, to play with the feeling of power and mastery. He is therefore not only gaining mastery over the painting tools themselves, but also over visual changes and events taking place in the behaviour of paint, and we could think of this as the *structure* of the painting. The representation of driving the car may, at a deeper level, represent his own desire to be in control of power, movement and the outcome of events, and we could think of this level as the *content* of the painting. It is important to remember the difference between the structure and content of the child's painting or drawing. What makes humans move is different from what makes objects move (Wolf, Rygh and Altshuler, 1984). Children use play with paint to sort this out.

Drawing and language

The above approaches to representation and expression are little understood and have received scant attention. Fucigna (1983, p. 1) points out that in early studies of language acquisition there is a similar problem. The way children represent in their drawings and paintings has been concealed rather than revealed through the definitions used. This has had a bad effect on education and childcare. Language acquisition moves along a continuum which has organisation and meaning right from the first sounds. This is true for all aspects of representation, of which language is one aspect. As babies learn to speak, they often practise sounds over and over again to themselves. At such times, they are not calling to anyone, but playing with the possible combinations and variations of sounds. It is essential for language acquisition that they do this. They learn about the structure of speech which they could not achieve by simply copying from older speakers. They are well motivated to do this. They

find speech sounds and speech actions interesting in themselves. Derek Bickerton (1981, p. 234) calls this 'infrastructural motivation'. It means that babies are motivated to find out how sounds are put together to make meaning.

The same is true of drawing. Children investigate and play with patterned sequences of action, and repeat, vary and combine these according to how they look in terms of shapes, colours and lines. There is more to this than the child just assembling a formal vocabulary of shapes. On the one hand, the child is starting to realise that drawing is made out of self-sufficient shapes and is not reliant on imitation of the visible world. On the other hand, the child is also seeing that there is a relationship between these visual structures and structures in the real world. It is this 'double-knowledge' which makes representation possible (Furth, 1969).

SUMMARY

In this chapter we have seen that very young children form some powerful approaches to representation and expression during the time when they are supposed to be merely scribbling. Children rarely scribble. Before they can barely talk, they are already forming a visual language of great eloquence and meaning. We should not be too surprised by this, given what we know now about other aspects of the beginnings of representational thought.

The start of visual representation in early childhood has been badly misunderstood by researchers, if recognised at all. This is largely because of the researchers' pre-conceptions or assumptions about what a painting or a drawing is. One assumption held is that children's drawings and paintings are delightful outpourings with which one should not interfere. At the other extreme, many researchers assume that the end-point of drawing development is when children show three-dimensional volumes in their pictures. Following on from this idea the earlier drawings are considered to be simply full of errors. These are the two extremely opposed positions but there are many shades and variations in between. Which version you believe will strongly influence how you provide for children's education in visual representation. If you feel that it is a wholly natural development which is basically unteachable then this will lead to a *laissez-faire* approach. If, on the other hand, like Piaget, you feel that young children are 'failed realists' (cited in Freeman, 1972, p. 133) then you will consider that children need to be trained in techniques to show depth in their drawings.

All of these approaches are wrong and also anachronistic when we consider

the range of practices considered as drawing by contemporary artists (for example, see Rose, 1992). Yet it is vital for both early and later learning that we identify and help these neglected ways of expression and representation in young children. If we do not, we have no basis for planning educational provision and childcare.

Drawing is a continuum which is organised and meaningful right from the outset. Children start to represent both the shape of objects and their movement. They start to use the event of painting to represent other events beyond the surface of the painting. In a process similar to language acquisition, children investigate the pattern or structure of their drawings and the actions which make them. They also imbue painting actions with a range of emotions. Even in the hands of a two year old, painting and drawing become sensitive media, responsive to delicate fluctuations in mood.

How do we support this process? A knowledge of, and interest in, art is extremely useful but this, by itself, is not enough. This is one of the reasons why the English Art National Curriculum is so poor. It is defined in terms of a definition of 'art' and its so-called 'basic elements' and how to teach these to children (Matthews, 1993). Such definitions can only be provisional, and are not central to education. Caregivers need to know what it is within this discipline 'art' (in terms of experiences and processes) which actually promotes development.

The beginnings of drawing and painting then are intelligent acts. Painting and drawing by the very young are complex events in space and time in which actions are given meaning. How does the child give meaning to drawing actions? To answer this question we have to go back to the origin of these actions in early infancy, to the beginning of representation itself.

2 ACTION, SKILLS AND MEANING

WHERE DO REPRESENTATIONS OF MOVEMENT AND OBJECTS COME FROM?

Early mark-making is part of a family of interrelated expressions and representations. We saw in the observation of Ben that he was representing the movement, shape and location of an object. Where did these understandings and abilities come from?

Recent studies of newborn babies show us that representational thought begins at, or soon after, birth (Bower, 1974; 1982; and Spelke, 1985). This is very different from the idea of the baby as an empty vessel. It reveals that babies come into the world equipped with two kinds of internal 'software'. One set consists of rudimentary ideas about objects and events, the other about understanding human beings.

Ingenious experiments with newborns show that when supported so that the arms are free, babies will reach out towards objects and even to illusory or 'virtual' objects. Bower and others showed that the babies will also respond with defensive actions of the head, arms and hands to 'looming' objects. These were startling findings. Their interpretation remains controversial but it does seem that the visual experience of babies is of a three-dimensional world. This is in stark contrast to the idea that the baby would only perceive objects as objects after experience.

Newborns are interested in the shape, form and movement of objects. In experiments by Elizabeth Spelke (1985), newborns seemed more surprised by changes in the paths of movement made by objects, than they were by abrupt changes in their form and colour. This suggests that babies are using aspects of the object's movement path to identify objects (rather than the object's shape or colour). Again, we could interpret this in different ways. However, we can say that babies arrive in the world with certain ideas and expectations about objects. It is as if babies have, in their brains, representations of how objects move, and are disturbed when these are disrupted.

CONVERSATIONS WITH NEWBORN BABIES

In addition to these remarkable abilities, newborns also seem predisposed early on to take part in conversations with people. These involve facial expression,

vocalisation, and gesture. The work of Stern (1977) and Trevarthen (1980) shows babies taking part in exquisitely orchestrated conversations with parents. Although stage-managed by the mother or father, these are by no means completely controlled or always initiated by them. The babies play a strong role in setting the theme, pace and tempo, and do not simply adapt to and copy existing behaviours. They play a part in the 'creation of culture' (Trevarthen and Grant, 1979, p. 566).

Watching video recordings frame by frame or in extreme slow-motion of our daughter Hannah (from only a few days old) together with Linda, her mother, reveals a beautiful 'interactional synchrony' (Condon, 1975) of vocalisations, facial expressions and gestures. Babies control a network of behaviours which are '... held together by emotional states of mind ...' (Trevarthen, 1984). One has the powerful sense that mother and baby are brought together in a common purpose or shared act of understanding (Trevarthen and Hubley, 1978). Trevarthen has suggested that the baby and caregiver are able to converse because each is able to detect in the other, subtle nuances of speech, facial and body movement which coordinate emotion, intention and motivation. Babies seem to be able to synchronise their own rhythmical patterns with those of their mother or father (Trevarthen, 1984; 1987). We will see how these early patterned games are gradually developed to include painting materials, sensitively supported by the caregiver.

THE BUBBLES OF SPACE BETWEEN CAREGIVER AND BABY

It is within this 'bubble' or psychological space (Stern, 1977, p. 29) formed between partners (caregiver and baby) that actions and then objects come to acquire special meanings. When Linda causes objects to enter into this space they are carefully introduced into Hannah's line of sight and eye focus. Linda plays and replays her actions in slow-motion, carefully adjusting speed and position to what she perceives to be Hannah's ability to look at and 'track' an object.

Piaget suggests that before a baby can communicate with another person, certain basic understandings have to be formed about both objects and space. Trevarthen has suggested that it might be the other way around: skills in the handling and manipulation of objects could be a result (not a cause) of a baby being able to communicate. In other words, the way babies think and feel about

objects and their movements may come about because of the way they communicate with people who are important to them (Vygotsky, 1986).

Drawing and painting start within the bubble of space formed between caregiver and child. How the adult interprets and responds to what the child does is crucial to the way the child begins to represent things. Clearly, language is part of this and the way the caregiver responds to the child's speech. There is nothing extraordinary about Hannah and Linda in this. Adults seem to like getting into conversations with babies, and most babies seem to be able to respond. There are some important implications here about childcare and education which will be followed up at the end of this chapter.

The timing, tempo and cadence of these conversations between baby and caregiver become the structure for later play, construction, drawing and painting. Condon's work (1975) showed that talking to babies made them move. The movement of their arms, legs and faces occurred in bursts which were linked with their parent's utterances. If a person makes objects move within the baby's visual field, this also brings about bursts of movement from the baby. Perhaps this is because adults imbue the object with human-type actions. In their experiments, Martin Richards and his colleagues found that babies responded differently to jerky, irregular movements and predictable, regular, mechanical movements in rolling ball bearings they were shown. Richards thought irregular movements might be similar to human movements and were therefore particularly interesting to babies (Richards, 1980). Filmed observations made during their first weeks of life show Ben, Joel and Hannah participating with enthusiasm to events occurring within this bubble of space between myself or Linda. At four days old, as I bend over her while she lies on her back, Hannah makes rhythmical arm and leg movements towards me. The movements are almost circular, alternating from one arm to the other. Each movement is a little like a crawl swimming stroke. This kind of behaviour, in which all the limbs and fingers are moved together in an excited response to a stimulus is called a synergistic response (Davies, in press). The same can be observed when children begin to paint and draw. As we shall see, early drawing and painting involve many movements, not only those of the drawing hand. It is as though the children are acting out an internal description, story, event or image they had in their minds, just as people use gestures of the hands, arms and face when in conversation with each other (Davies, 1969). Yet, all movements made by the children, apart from those of the drawing hand, are ignored by most researchers. They see drawing as the mapping of three-dimensional volumes onto two-dimensional surfaces. This has some disastrous consequences for our understanding and provision for children's visual

representation. It is a mistake to think of drawing and painting in such a narrow, simplistic way.

Babies study the movement of objects, but they are also interested in the movements of their own bodies. At first they move when they see interesting objects. Gradually, they begin to sort out the different movements they can make.

Babies and movement

Babies become aware of their own movements very gradually. It may be that initially babies are unaware that they themselves cause their bodies to move. At fourteen days old, Hannah catches sight of her own fist as it flies past her face. She tracks its trajectory as she would that of any other moving object. It may be that she does not realise the fist is her own. Realising that there is a relationship between our own actions and their effects is the basis for later expression and representation.

Soon, babies seem to move their arms, fingers and legs as if for the sole purpose of studying these movements. By the age of two months, for example, Hannah holds her hand in front of her face, gently rotating it back and forth on an axis. She studies it intently. It is no longer a question of her catching sight of her fist as it fortuitously zips across her field of vision. She is now able to hold her hand steady in front of her eyes in order to move it and look at it. She moves her hand away from her and, at the moment of furthest reach, gracefully fans out her fingers. It is as if she is breaking down actions into their component units and analysing them. She also bangs her palm against surfaces and then holds her hand before her eyes and gazes at it with interest (see also Bower, 1982; and White, Castle and Held, 1964 for a full discussion of hand-regard).

Three movements will be useful to Hannah when she begins to draw. These are making a vertical arc, a horizontal arc and a push-pull (Matthews, 1983; 1984). The way each develops is complex. The development of each action can be described separately but it is important to appreciate that they are members of a family and that they interact with each other.

Vertical arc

The vertical arc is linked with the way a baby understands an object or person as something to use as a target. Hannah is sixteen days old. A multi-coloured cube is presented within her visual field. She swipes at the cube with a downwards circular action.

Babies, right from birth, cannot resist reaching towards objects. This is the beginning of the vertical arc. People are targeted in the same way. A few days later Hannah smiles excitedly when Joel approaches and plays with her. She swipes her hand in vertical arcs towards him. These early movements are put to different uses, but are all equally important. For example, babies test and investigate objects and surfaces by striking them; and reach out towards people, or point out objects to them. These movements form part of a rhythmical game with a partner, in which stampings and beatings of the hands and/or feet are used. The players imitate and extend each other's movements. What is perhaps surprising is the precision of the baby, whose movements alternate with those of the partner with a fine sense of timing. It is unlikely the baby is copying, as the baby plays a strong part in initiating these games and in controlling their intensity and length. At around two years' of age, for example, rhythmical patterns of hand movements, feet stampings or hand slappings are initiated by Hannah with a single slap of the hand.

Later we will see how Hannah develops these games, so that by the age of two it includes painting processes, in beautifully coordinated, rhythmic sequences of action, sensitively supported by Linda, her mother.

Looking at filmed observations of Hannah and her mother show that, once the games have started, it is sometimes hard to work out who is the leader and who is the follower. The sensitive parent responds to subtle movements of the baby, imitating, repeating and extending them. In a way, the adult makes a continuous 'commentary' on the baby's actions (Harris, 1989, p. 22). A conversation is created made up of vocalisation, facial expression and gestures.

There are some important teaching implications here about the kind and quality of support which might foster children's development and learning. These will be mentioned at the end of this chapter. Because these early movements are used for communication as well as for mastery of objects, the movements are saturated with emotion. This has consequences later on in the child's life when they are applied to drawing and painting situations. We shall see these patterned movements transferred to drawing and painting.

Horizontal arc

Vertical and horizontal arcs are interwoven as they develop and become basic mark-making movements. The vertical arc develops fairly rapidly over the first and second months – for swiping at objects; for outward reach and grasp and as an excited response to people. But the horizontal arc only really begins to develop when the baby can be propped to sit up and reach horizontal surfaces.

For Hannah this occurred at about three months of age. She used it as a fanning or wiping gesture, usually across a smooth horizontal surface. She also made semi-circular arcs back and forth in front of the middle of her chest. This is an early form of the movement Ben used at age two years and one month with a brush, to start his painting.

The following example is from slow-motion film recordings of Hannah: Hannah is three months old and she sits in her little chair, with her meal tray before her. She sweeps her hand across her tray towards a wooden rattle. Sometimes, using this action, she knocks the rattle onto the floor.

She is beginning to build up knowledge about the relationship between objects and the surfaces they rest on, as well as her knowledge of her own movements. One interesting discovery is that objects can be slid and scattered along and off horizontal surfaces. For this manoeuvre she learns to use the horizontal arc. She finds she can gather up and capture objects.

Typically, a parent will offer an object to a baby at around the centre of the baby's chest. When objects are dangled around this 'hot-spot' as it has been termed (Gray, 1978, p. 168) the baby will look at it and the hands will then close in upon it from both sides. Hannah at three months and four days was lying on her back. An object was dangled at the centre of her chest and she moved both her arms towards it at this central 'hot-spot'. Nineteen days later, she used horizontal and vertical arcs in three ways:

- to contact objects;
- to gather objects;
- to scatter objects.

In particular, Hannah has developed an all-purpose downward striking movement which she applies with gusto to a range of objects and surfaces. Hannah keeps modifying her movements depending where the object is. We can see her using her own body as a landmark. This helps her to control the natural swingings and stabbings of her arm and hand by relating these movements to her central 'hot-spot'. It takes excruciating concentration. Sometimes she manages to control the way her hands meet in front of her chest so that they clasp each other, and (even sometimes) clasp the desired object!

Later we will see how 'landmarks', such as the position of an object, and parts of the body, become coordinated and begin to play an important part in early drawings and painting.

Push-pull

The push-pull, the last of the trio of mark-making gestures, does not really make an appearance until the fourth month, because the baby must be able to grasp an object. Babies need to understand the difference between reaching and grasping in order to hold pencils, brushes etc., and to draw and paint. This means that before looking in detail at 'push-pull' movements it is necessary to make a detour in order to consider how the baby develops reaching and grasping skills.

Reaching and grasping

To make skilful actions designed to carry out a particular purpose means being able to organise sequences or patterns of movements in time and space (Connolly, 1975). In order to reach and grasp objects, babies need to differentiate the different movements which, first of all, are fused together in one pattern (Connolly, 1975; Bower, 1982; Von Hofsten, 1983; and Trevarthen, 1984). 'As long as reaching and grasping are coalesced into a single act, tool use is not possible' (Bower, 1982, p. 175). Babies try hard to analyse and correct their movements. We have already seen earlier in the chapter that they find their own movements and the results of these interesting.

Hannah aged two months and nine days old, is lying quietly in bed on her back. In the absence of any object she makes repeated reaching and grasping movements whilst intently watching her hand. She holds her closed fist close to her face for a moment, studying it. The elbow is bent in this position. Then she moves her fist away from her, using an over-arm arc. At the end of its trajectory the arm is outstretched whilst the fingers gracefully fan out. She does this dozens of times, watching with a rapt expression. Hannah seems to be repeating the separate movements of reaching and grasping without an object. We see her taking apart sequences of action as if to analyse them, and gain complete understanding and mastery of them. We will see this careful monitoring and adjustment of actions again and again.

The films made of her when she was about four months old show her developing and analysing the skills involved in picking up and holding an object. She adjusts the position of her fingers and palm to fit the shape of the object she wants to hold. This 'in-flight' correction is an important achievement (Bower, 1982, p. 175). Hannah is practising, analysing and coordinating the schemas of looking, reaching and grasping. These are the fundamental skills for the use of tools, such as pencils and brushes. They will be useful for drawing

and painting later on.

When Ben was painting, using the horizontal arc as he did so, he also used the push-pull movement. Like the horizontal arc, the push-pull requires him to make an arm and hand movement along a flat, usually horizontal, plane. Ben has to adapt his movements because the push-pull uses the elbow. The push-pull is usually made using an object on a surface. Ben holds a paintbrush and paints onto paper on the table. The push-pull is therefore a more advanced movement. It joins the family of movements where objects can be held in the hand and manipulated.

It is not glimpsed in Hannah's movements until she is about three months old, when she is learning to push and pull objects on flat, smooth, horizontal surfaces. At age three months and four days, using two hands, she holds a bowl by a section of the rim nearest her and pushes it to and from herself along the surface of the table, in sudden bursts of action. Over the next days and weeks she learns the difference between 'push' and 'pull' and finds important uses for each. Thirteen days later, for example, she can push her bowl away from her or pull it towards her – whichever she wants.

Because children find the effects of their movements interesting they repeat and develop them. They start to select movements on the basis to suit their purposes. For example, the push-pull is particularly effective for a wheeled toy. At five months old Hannah repeatedly pushed and pulled a little wooden, wheeled dog to and from herself on the floor.

SUMMARY

From birth, babies create a family of strategies through which to investigate objects and surfaces. They gradually begin to reach and grasp, swipe and fan, and in so doing obtain different effects. As the months pass they learn to adapt these actions to suit their different needs. It is not enough to describe this process in terms of object mastery alone, because the baby organises actions into expressive sequences. This happens because the actions emerge in social contexts. The baby employs movement in playful exchanges with people, and in order to communicate with them. This means that the baby's actions are invested with a range of emotional values. Movements are given meaning in a joint enterprise of child and adult comparison. In the next chapter we shall see how this play of patterned movements is transferred to drawing and painting.

3 THE BEGINNING OF PAINTING AND DRAWING

THREE DIMENSIONS – OBJECTS AND PEOPLE

The last chapter showed that development and learning are not passive processes but involve babies in actively searching the environment for the experiences which will help them as they grow. We have seen how the baby creates a set or family of strategies through which to investigate all kinds of objects and surfaces. This interest existed at birth. Depending on the object and the movement used to investigate it (reaching and grasping, or swiping and fanning) different effects are obtained. The range of objects explored and contacted is very great, including objects which are clearly three-dimensional; objects which, when struck, might roll or tumble or perhaps fall and break. Throughout these investigations, babies adapt their actions in the light of what happens. This is part of the process termed 'accommodation' by Piaget. For example, Hannah learns to set overturned toys upright with a guided pull and grasp.

TWO DIMENSIONS – PICTURES

Babies also investigate other objects which are not so clearly three-dimensional. These include very flat objects on flat surfaces. Babies can be seen studying and scratching at small specks and spots of material. They can be surprisingly adept at picking up miniscule items like hairs. In this way babies gain a great deal of knowledge about surfaces, boundaries and volumes of objects.

Other things they see and which attract their interest include those which cannot actually be picked up at all, such as pictures. Bower (1974; 1982) has claimed that children are not fooled by pictures, and it is certainly true that they do not behave as if these were real objects. Nevertheless, my own observations show that babies reach towards two-dimensional images as if to grasp them. I speculate that although they might realise that these are in fact ungraspable, they are compelled to explore the characteristics of pictures with the action schemas they have available to them. In my studies, the babies, after scratching at the edges of the picture and finding no physical change, would then move

their hands out to the edges of the pages of the book or the picture as if to locate the true boundaries of the objects.

First painting

Joel, at just over six months, is lying on his stomach on a purple carpet. He regurgitates some milk onto the carpet in front of him, presenting a contrasting, white circular patch before his eyes. He reaches his fingers into this irresistible visual target and makes a scratching movement. He hears his fingers scratching into the carpet, and he seems to be watching with interest the effects of his own movements. He seems to be interested in the changes he is causing to take place.

Hannah and Ben also searched small pools of spilt milk, locating edges and boundaries. Such behaviour might appear trivial (or even unpleasant!) to some people but there are several important aspects to be considered here. Joel has modified his movements – finding the milk ungraspable, he modified his grasping to a scratching motion.

When a baby begins the scratching movement, a trace of milk is left behind. This is unique to the situation where the baby is using a mark-making substance, like paint, or in this case milk! It leaves a record of the baby's action. The baby realises that he or she has the power to create changes in the environment.

The beginning of painting and drawing occupies a unique place in a baby's life. It offers the baby lasting information about the characteristics of his or her movements through space. It also offers the baby powerful expressive possibilities. The baby needs to know the difference between the movements and the marks which arise from the movements.

We have seen in the observations of Hannah and Ben that they are beginning to make this relationship – they realise that movement results in a mark. Ben goes on to understand that the mark made is determined by the movement made. This means that the baby begins to guide drawing or painting according to the marks he or she sees occurring. It is this intense feedback, unique to drawing and painting, which helps the baby put different movements together in new ways. Eventually, this process will allow the baby to consciously produce different shapes.

Realising that movements make marks

Initially, the baby makes marks with his or her hands (and sometimes feet) in various liquids. At around the same time (perhaps eight months) the baby

might notice an interesting effect caused by dashing certain kinds of objects against surfaces. These objects are mark-making instruments of various kinds. They leave marks in their wake as they travel along surfaces – the 'trace-making effects' described by Michotte (1963, p. 289). The baby looks carefully at the points of these instruments and discovers which positions and movements of the marker against the mark-receiving surface make interesting effects on it. He/she then experiments with various actions and relationships of marker to surface, clearly in order to establish how the marks are made (Smith, 1972; Matthews, 1983; 1984; 1986; 1988), when the marks appear, and when they fail to appear. Sometimes the baby slides a pencil along on its side, or presses its non-drawing end against the surface. The baby is very interested in the marks produced by bare hands and those produced by drawing tools.

The baby has understood the most basic principle of drawing, that a movement results in a mark. Moving on from this, the baby starts to realise that different actions result in different effects. Earlier on, the baby investigated and analysed objects and what made them move. Now, the structure of marks and the movements which make them are investigated and analysed in the same way.

In the early days paint is to be slapped, smeared, stamped and sat in! Ben, sitting on the floor at the age of one year and four months paints with a brush, on the floor and all around his own body (Matthews, 1983). The beginnings of painting and drawing are not just a reflection of the natural actions of the body. The brush, an object, forces the toddler to modify and change. So does the surface the brush is used upon. The object (three-dimensional) now meets a surface (two-dimensional) and makes marks (two-dimensional) on it. This calls for some fine tuning of the drawing actions, but some children have made these modifications by the end of their first year.

Horizontal arc

Joel, at thirteen months of age, has learned to toddle. He also likes to carry his cup of milk around with him. However, coordinating these two new skills is not easy and he frequently spills milk. On one occasion, the milk falls onto a smooth, shiny concrete floor. Joel, his jaw dropping, watches with great interest the spreading white shape. Then, he puts his right hand into the milk and starts to smear it, using the horizontal arcing motion. He quickly brings his other hand into play, so that both hands are fanning to and fro in synchrony, meeting at the midline, until they became out of phase. In this way he makes two sectors of a circle in the spilt milk (see Figures 3.1, 3.2 and 3.3).

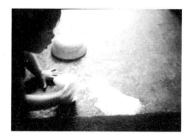

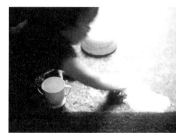

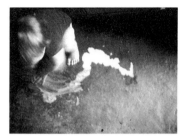

Figure 3.1 Joel spills milk and looks at it

Figure 3.2 Joel reaches his hand into the spilt milk

Figure 3.3 Joel smears the milk with horizontal arc movements made with both hands

It is important to realise that Joel's recently acquired skill in walking has in itself literally and metaphorically opened up new vistas for him. Such achievements signal not only a change in what the child can do but also a change in the child's *relationship* with the world (Costall, 1992).

JOEL BEGINS TO DRAW AND PAINT

I have suggested that the apparent 'accidental' nature of children's early painting and drawing may, in many accounts, have been overemphasised. There is nothing accidental about Joel's horizontal arc in the milk at thirteen months. He has passed through the struggle of mastering this, and can now draw one. Almost as soon as he has mastered it he will need to modify and change it, as demanded by new situations.

He modifies his horizontal arc three weeks later when he uses a brush and orange paint to make a horizontal arcing trace on my studio floor. Before, he used the palm of his hand in milk to make his arc, now it has been extended or 'amplified' (to use Jerome Bruner's 1964 term) because he is using a brush. He tries all sorts of movements with the brush to get to know its possibilities. First of all, crouching on his haunches, he waves the brush in an arc in the air, causing droplets to fly off. The filmed observations show Joel carefully looking at the trail of droplets as they make an arc on the floor. Perhaps finding himself unsteady in this position, he stands up. This seems to prompt a different movement – a vigorous stabbing motion of the brush in the air. This is a version of the vertical arc which meets empty space rather than a surface. Again, droplets of paint cascade onto the floor. There is definitely nothing accidental about this, Joel knows what he is doing. He knows that milk can be spurted from the spout of a shaken drinking cup, and uses this knowledge with the brush and paint. My detailed recorded observations show that Joel chooses,

from a whole set of possibilities an expressive movement. Joel knows when to use it; how to use it; and what it is good for. (See Figures 3.4 to 3.9 below.)

Between thirteen and fourteen months Joel keeps repeating vertical and horizontal arcing movements. Because we know that Joel at this time has a range of options open to him we can be fairly certain that when he reaches into the milk, or applies the brush to the floor, he does so with the intention of making that movement.

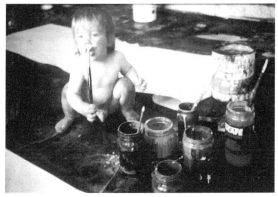

Figure 3.4 Joel investigates the brush with the sucking schema

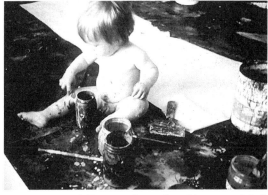

Figure 3.5 Joel discovers the mark-making potential of paint

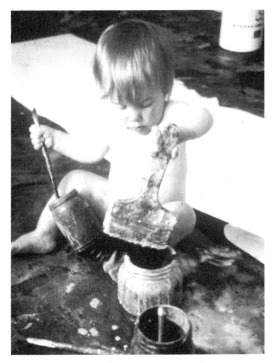

Figure 3.6 Joel builds up a knowledge of inside-outside relationships

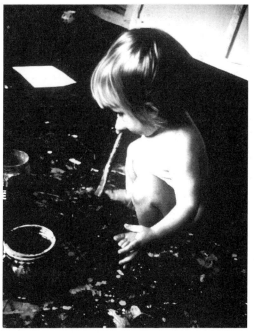

Figure 3.7 The child's exploration is systematic, not haphazard. Having discovered he can paint one surface one colour, he goes on to paint another surface another colour – he paints his toe-nails red

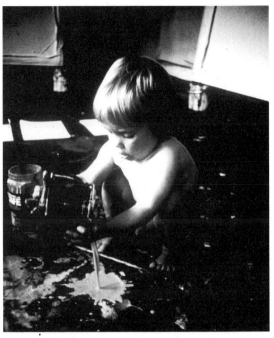

Figure 3.8 The horizontal arc applied with a brush

Figure 3.9 He learns about emptiness and fullness and the possibilities of paint

SUMMARY

Between the ages of one to two years of age, children begin to understand the connection between certain movements and certain marks. Part of this development is made possible because of the way pencils and brushes make chance collisions, but to call this accidental is misleading; an accident means that something unintended has occurred. Children respond to whatever opportunities arise during painting, and we must not miss out the interplay between what a child chooses to do and the chance marks which appear. Sometimes patches of paint or shapes just happen to correspond to shapes of objects, and the child will see a relationship between the shapes appearing on the drawing surface and shapes in the world. Children are naturally interested in marks and movements for their own sake, independent of representational meaning and will free-flow (Bruce, 1991) between these concerns. Dennie Wolf (1989) suggests that speech, movement and marks 'speak' to each other. When very young children paint it appears to be a chaotic act in the recent sense that apparent turbulence in fact conceals substructures of highly organised, law-abiding, patterned sequences and periodicities, as Bruce (1991) stated with regards to play. Clearly, it is essential for teaching and childcare that we identify and illuminate the nature of this order within the chaos.

4 MOVEMENT INTO SHAPE

SEPARATING AND COMBINING MOVEMENT AND SHAPES

Before their second birthday, most children have already learnt that different movements make different shapes. Ben, for example, at twenty-one months uses very different movements to make a contrast between shapes. He uses existing marks or lines on the paper as targets. He often disects these, drawing arcs or push-pulls across them. Or else he clusters dots or blobs at the beginnings or ends of lines (see Figure 4.1). According to Athey (1990) the beginnings and ends of lines seem to be important landmarks for children of this age as well as later on. Hannah clusters marks at the beginnings and ends of lines, or groups the marks she makes around angles formed by arcing or push-pulling movements (see Figure 4.2, overleaf). Alan Costall (1992) has said that recent work on computer vision suggests that such shapes may be the basis of how we see form and depth in the world. Bower (1974; 1982) suggests that the baby's interest in these shapes may start from the interest they show at birth in contrasts of light intensity and texture, and variations in the shapes in and around the mother's eye. The formation of lines and shapes and colours they see on the painting or drawing surface 'tell' Ben and Hannah something about the world.

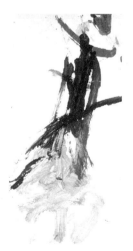

Figure 4.1 *Ben, aged one year and nine months, makes contrasting painting movements. Blobs are clustered at the ends of lines; pull lines are disected by arcs*

Ben at this time responds to, and learns to create, other dramatic contrasts of direction. He likes to make angles and lines which cut through, or even bisect, other lines. He likes to put lines against dots or blobs. The basic movements of

his hand and arm as he draws are the horizontal arc, the push-pull and the vertical arc.

A family of shapes

Children seem to be increasingly attracted to making angular and criss-cross shapes which often emerge as early as one year of age, and those are certainly very clear in paintings and drawings produced by Ben and Joel at eighteen months of age (see Figure 4.3). In paintings by children at this time, horizontal arcing movements suddenly change direction as the painting arm pulls the brush back towards the body. This is the start of a family of shapes. Children begin to separate out and to *classify* lines and actions, and this is actually the beginning of a behaviour and understanding which can truly be defined as mathematical.

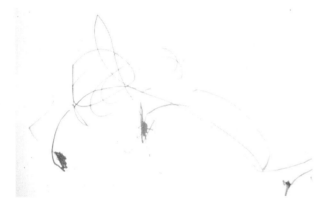

Figure 4.2 Hannah, aged two, marks the ends of lines

Figure 4.3 Joel, aged one year and eight months, makes angular shapes

Push and pull

At about eighteen months Ben, Joel and Hannah begin to separate push actions from pull actions. Sometimes this results in single lines on the paper. Although this is the start of a vertical line, strictly speaking we should be careful about naming these early, single lines true 'verticals' since they are the result of body movements. However, it is the start of a vertical direction on the drawing surface.

From about fifteen months Hannah contrasts two arcing movements of the brush – one making a right angle with the other. She makes a different contrast by energetically varying the way she moves her wrist and arm, yet maintains continuous contact with the paper so that lines make angles with the lines

already made. This is a pattern of movement which Hannah uses repeatedly up to the age of two (see Figure 4.4). She also makes little star shapes.

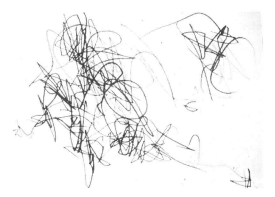

Figure 4.4 Hannah, aged one year and eleven months, makes little star shapes

Children repeat these and other contrasting combinations and create variations. Children seem to enjoy making contrasting shapes and contrasting shapes are made because children like to vary their movements in contrasting ways. The movements are patterned in time as well as space. As yet we do not know enough about these patterns of movement.

Making connections

From around two years of age, children start to make separate yet linked shapes, and we have seen how reach and grasp become separated but linked. The same occurs when movement is separated from the marks made on paper. When children distinguish between the marks and the movements which made them, new possibilities occur. They can now separate the different parts of lines and shapes and link and combine them in various ways (see Figure 4.5 created when Hannah was aged two years and four months).

Figure 4.5 'I show mummy' by Hannah, aged two years and four months

Drawing helps us see and understand

Contrasts in three-dimensional and two-dimensional situations fascinate children. We can see this in Ben, Joel and Hannah between the ages of three and four when their interest in right-angles alerts them to letter formations they see. This is a part of what has been termed 'developmental' or 'emergent' writing. This will be discussed later in Chapter 9. The American psychologist James Gibson (1966) proposes the interesting idea that in pre-historical times the act of drawing started and guided a different way of seeing and understanding the world. In everyday life, it is necessary to quickly identify objects, animals and spaces for purely practical purposes or for reasons of survival. Creating pictures meant that people could start to appreciate shape and form for quite different reasons. The same process may have occurred with the use of colour, in painting. Colour serves an important survival function because it adds enormously to visual information. Perhaps painting similarly prompted a different understanding and use of colour.

USING COLOUR: CONTRASTS AND LINKS

One of the ways very young children use colour is to 'colour-code' each drawing or painting movement, almost according to the rules of a game in time and space. It is as though children feel that each movement and each mark deserves its own special, distinguishing colour. In this way children link movement, shapes and colours, and at the same time, sounds.

Ben, aged one year and eleven months finds a piece of A4 size paper which had been folded (by an adult) into four so that, unfolded, the paper is divided into four rectangles by the clear creases. Ben marks each of these rectangles with a different shape. Then, using small, intense arcings of the crayon, he superimposes black, over green, over orange, each additional layer bisecting the previous layer at a contrasting angle. He is actively trying to differentiate and separate things out. This is important when children begin to move into two-dimensional construction. Ben is also orchestrating movements with the marks he makes on paper. He notices the effects on his 'targets' as he draws. He covers one layer with another. In Chapter 5, we shall see how this leads to the representation of one object in front of or behind another. This is termed a *projective* relationship, through which Ben tries to put the three-dimensional world on to two-dimensional paper. Because of a limited definition of drawing, most researchers do not realise that projective relationships are present in the drawings of very young children.

The way Ben targets what he has already drawn means he draws one thing on top of another. Different colours are layered one upon another, and he chooses where. In a felt-tip drawing Hannah, aged two years and one month, chooses the ends of lines. So, in covering, the toddler is starting to bring about and see colour changes taking place. Hannah and Ben are learning to mix colours. It is also interesting to note that Ben, Joel and Hannah all aim at the mark with great accuracy, and even if the pencil skids around, the first impact – even at small points – is very accurate. (Freeman, 1980, has found this is true of older, so-called 'scribblers'.)

The importance of marks and the spaces between them

Sometimes an empty space is chosen as a target for mark-making. Joel, aged eighteen months produces a series of pull lines, placed side by side (see Figure 4.6). He carefully separates nearly every line from its neighbour with a gap. This is the beginning of composition. Claire Golomb (1992) writes very interestingly about the different ways children compose their pictures and how these become integrated as they grow older. Nancy Smith (1983) and Pat Tarr (1990) have also written sensitively about the very young child's arrangements of marks on paper. Other researchers seem to regard composition as a sort of optional extra to the real concerns of showing space and shape. This is nonsensical of course, because composition is involved at every level in drawing skills. It is impossible to analyse how children draw the relationships between objects without also looking at their composition.

Figure 4.6 Joel, aged one year and six months, places lines side by side, leaving gaps between them

THE BEGINNING OF COMPOSITION

Composition involves a child's movements. Joel separates not only each mark, but also each marking movement, by replacing and removing each pen cap

between each stroke! At other times he puts his fingers into them. He seems to be using them as finger puppets, sometimes speaking to them or pretending they can speak. Chris Athey tells me that she has also noticed children playing with pen caps in this way. Like other movements, they are not an irrelevance but deeply important as drawing and painting develop. In play, Joel is temporarily released from the struggle of adapting his movements to the function of the pens. He has the freedom to manipulate them in very different ways and to find out all sorts of ways to use them. He has the opportunity to give them grace and style. So, talking to your pens affects your drawing!

Joel is very selective about where he puts his marks in space. In a small drawing book at this time, he starts a new page for each mark. This is important in terms of early writing and mathematical logic. It may also show Joel's understandings of objects in space (Bower, 1974; 1982; and Athey, 1990).

Points in space

Sometimes Joel makes layers of marks, sometimes he clusters them in tight groups; and at other times they are scattered across a wide area, or all in one carefully restricted place. Each mark on the paper seems to be a unique event. Each new impact of the brush seems to be an attempt to repeat this unique event.

Continuous rotations

By the age of one year and eleven months, Ben's, Joel's and Hannah's push-pulls and arcs are becoming far more controlled and can be more or less expansive, by adapting the movements of the wrist, elbow and shoulder – they become *continuous rotations*. See Figure 4.7 drawn when Ben was aged two

Figure 4.7 Ben, aged two years and nine months, makes a continuous rotation

years and nine months. He said this picture was 'the big wheel' from a visit to the fairground. Is he representing the movement or shape of the wheel? (See also Matthews, 1983; 1984; 1988.)

Continuous rotation allows for changes of speed, both faster and slower. Nancy Smith (1972, p. 70) suggests that these continuous rotations enable a child to make a prolonged movement. This is hard to do with other sorts of movements. It was not possible with arcs and push-pulls. When children run along a long beach, they can make a very long, straight line, but usually the line has to stop rather abruptly because space runs out.

THE BEGINNING OF SKETCHING

When children begin to make large rotations, at the same time they love to 'cover' an area of paper. Of course, it is relatively straightforward to do this with paint and a large brush. Ben covers an A2 sheet of paper with red and pink paint and says it is, 'Toast and jam with Gypsy.' Gypsy was a friend of his. The surface of the paper represented the surface of the toast, and the spreading of the paint represented the spreading of the jam. In this case, rotational or other movements are sufficient to cause surfaces to be actually, physically covered with paint. When armed only with a fine-tipped pencil or a felt-tip pen, the intention still seems to be to cover an area – but it is more difficult of course. This suggests that children before the age of two are developing a sophisticated 'sketching' technique. Speed is of the essence, and the spare and open weave of lines is understood by the child to show completely in-filled areas. It seems likely that the beginnings of sketching can be glimpsed in the continuous rotational marks made by young children. Later we shall see how Joel uses early sketching techniques. The idea that 'sketching' does not appear until children are much older (Fenson, 1985) needs to be looked at again. I certainly do not believe this to be true and would argue that sketching appears very early on in the development of drawing.

Many accounts of children's drawing stress the process through which children select (from so-called 'scribbling') clear shapes like circles and lines which they combine to make designs and pictures (for example, Kellogg, 1969). However, this is only part of the story. The child also explores the continuous-contact line (misnamed by adults as 'scribble'). These two interrelated processes, the making of clearly defined shapes and the continuous-contact line, are entwined together, and enrich each other. Together, they help the child become fluent in drawing.

Closed shape

Usually, it is through using rotational movements that children discover how to make a *closed shape*. This is extremely important in drawing development. As Arnheim writes (1954), space is never neutral. The closed shape creates two very different regions separated by a line. It separates a portion of space from the surrounding area. Very young children quickly learn to use it, for example to show a 'face' (of an object or person) or to represent inside and outside relationships. This interest may reflect the child's changing understanding of space and volume. Children modify their understanding that two objects cannot occupy one space. They begin to draw one object inside another (Bower, 1974; 1982; and Athey, 1990). In Figure 4.8 drawn when Joel was nearly two-and-a-

Figure 4.8 *Joel, aged two years and five months, draws a closed shape and places a mark inside it*

half, he explains the drawing as, 'There's a baby in here. A baby in the water.' In another drawing, he put different marks into different parts of his closed shapes, therefore beginning to *classify* the different marks. This is the start of mathematical logic.

The representation of inside and outside relations, using the closed shape and the rotational marks, will only occur if the child is already developing these ideas. When children begin to use the closed shape in their drawings, this generally means that there has been an important shift, not only in motor control but also in the development of thinking.

Closed shapes are different from other shapes

The closed shape is one of a family of shapes which are created. Arnheim (1954) suggests that shapes cannot only be put together, they can also be taken apart. For example, Hannah at the age of sixteen months pulls lines over the edge of a piece of paper, making a roughly parallel series. By the age of two these are

being arranged in roughly parallel, longitudinal series. We must be cautious about calling these lines 'vertical' since they are really the result of actions made to and from her body. Hannah begins to move the pencil in opposite directions. This means that gradually vertical and horizontal lines relate to each other.

Children begin to use a line to join two separate marks or patches together. At around the age of two Hannah is in sufficient control of a continuously rotating line to enclose dots or other marks. As she plays, she develops her ideas and feelings about places on paper, how they link, whether they are continuous or separated. Her play helps to guide her drawing.

Combining movements and marks: travelling zig-zags and travelling loops

Travelling zig-zags

At around two years of age Ben, Joel and Hannah are all able to separate out, or combine together, the different parts of movements and shapes. They can group lines and marks in ways which are logicomathematical, rhythmical, spatial, and musical. They can put together movements which were separate to make new ones. In this way new shapes are created. Between the ages of twenty-three and twenty-six months both Hannah and Ben combined a push-pull movement with a sideways movement of the drawing hand to produce a *travelling zig-zag*. In Figure 4.9 Hannah, at a slightly later age of three years and three months, makes a *travelling zig-zag* whilst saying, 'The clouds are moving along slowly.'

Figure 4.9 Hannah, aged three years and three months, makes travelling zig-zags

Travelling loops

A *travelling loop* is created by a push-pull which crosses back over itself between pull and push. Before this, 'e' shapes of various kinds, waves and little spirals have been discovered. In Figure 4.10 (overleaf) Hannah, aged three years and two months makes a *travelling loop* whilst saying, 'The bubbles are going up to

the surface'. She may be establishing a vertical axis and higher and lower relationships.

Figure 4.10 Hannah, aged three years and two months, makes a travelling loop

Different movements have different results

Children explore the relationship between their movements in different contexts and in different media over and over again. Hannah, aged two years and seven months, sits at the kitchen table which is covered with a vinyl sheet. She splashes milk from her cup onto the table and this forms striking patterns as it spreads across the shiny surface. She studies the white shapes intently and practises, in sequence, distinctly different marking actions. First of all, looking very closely at what she is doing, she trails a line through the milk using one finger, then she trails four fingers through it. She attends very closely to the effects of her actions. She is seeing that different movements have different results. Then she makes another action which she has also practised in a variety of settings. She makes an intense and fast rotation in the milk with the palm of her hand (see Figure 4.11).

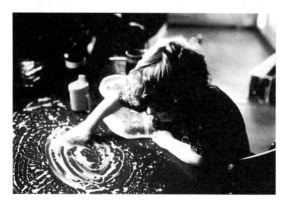

Figure 4.11 Hannah, aged two years and seven months, makes a continuous rotation in milk

Combining different drawing actions

Hannah can make a variety of straight lines and circular shapes. She has become an expert at producing these and other shapes. From two years and one month Hannah's rotational shape is quite accomplished. She can combine or separate marks and marking actions at will. She can play around with variations of speed and intensity. She can choose to spiral inwards or outwards according to whim. She can slow down and curtail the rotational movement to create near single-line enclosures. In this way she can produce a shape which we have seen is very important to drawing development: the closed shape. Or she can attach the lines to the closed shape to make another very important visual form: the *core and radial* (see Figure 4.12) (Athey, 1990). Joel and Ben were also able to produce these shapes at around the same age.

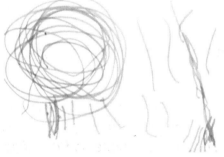

Figure 4.12 Hannah, aged two years and six months, makes a core and radial

Children need to practise and repeat what they know

These discoveries are not made once and for all. What is discovered on one occasion may not necessarily be remembered. The same discoveries might need to be made several times. Even when shapes are put together it might be necessary for the child to repeatedly take them apart again in order to really establish how the different parts relate together, and how movements and shape relate to each other. The child does not necessarily abandon earlier forms of drawing action in favour of later ones. As we saw, Hannah investigated and reinvestigated the same things over and over again, and will continue to do so, in different contexts and in different media.

However, each new experience is not simply a repetition. Each new version adds some new quality or understanding to the shapes and movements which produced them; subtle or radical permutations and overlays of emotion. It may be true, as Claire Golomb (1992) writes, that prior scribbling experience is not necessary for the child to draw certain shapes, for example the closed shape.

However, it is likely that these shapes will remain primitive without practice. Children without practice seem unable to put shapes together in new ways. Through practice, both the basic shapes and the structural principles which produced them become enriched by new possibilities.

By the age of two-and-a-half, Ben, Joel and Hannah are all well on the way to producing a variety of lines and shapes. Figures 4.13 to 4.17 show examples of the shapes practised by Ben between the ages of two years and ten months and three years and two months. They show continuous rotation (see Figure 4.13); closed shapes (see Figures 4.14 and 4.16); parallel lines (see Figures 4.15 and 4.17); a development of core and radial – the tadpole figure (see Figure 4.15); right-angular connections (see Figures 4.16 and 4.17); disection (see Figure 4.16) and travelling zig-zags (see Figure 4.14). The shapes are practised for their own sake but may also have representational values. Figure 4.17, for example, shows a man fighting snakes in a snake pit.

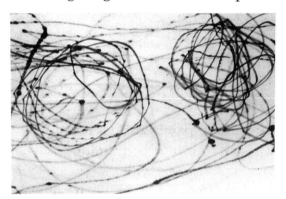

Figure 4.13 Ben's continuous rotations, aged two years and ten months

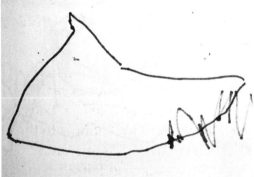

Figure 4.14 Closed shape and travelling zig-zag, by Ben aged three years and one month

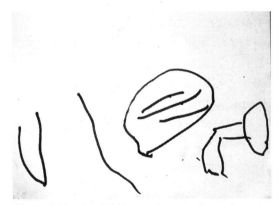

Figure 4.15 Parallel lines and tadpole figure, by Ben aged three years and two months

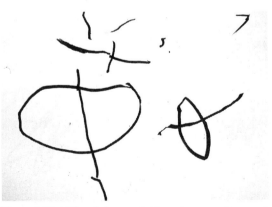

Figure 4.16 Closed shapes, right-angle connections and disections, by Ben aged three years and two months

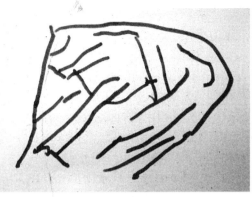

Figure 4.17 Parallel lines and right angle connections represent a man fighting snakes in a snake pit by Ben aged three years and two months

TRADITIONAL DRAWING MEDIA AND ELECTRONIC PAINT

Changing the medium causes variations in children's drawing actions. John Jessel and I introduced children between the ages of one year and ten months and three years and ten months to the microcomputer paintbox (Matthews and Jessel, 1993a; 1933b). We compared the drawings they produced in traditional media (pencils, coloured felt-tip pens or crayons and paper) with those produced in 'electronic paint'. This medium differs from traditional painting and drawing media in important ways. The drawing surface and the display surface are separated and are at right angles to each other. There is no physical texture to electronic paint, colour does not 'run out' or mix on the surface. Nor is there any loss of luminosity. Sometimes the screen displays only a small part of one's drawing action and we observed Robert (aged three years and one month) slowing his drawing movements in order to be sure that this was the case.

Yet even with these differences we found that children used horizontal arcs and push-pulls to make links between their movements and the visual effects. They also went on to produce continuous rotations, grids, and closures. We found that one drawing movement, the vertical arc, was radically modified because, with the mouse-driven computer, movements made in the third dimension do not affect the quality of the drawing on the screen.

The example of the computer paintbox shows that children use the same powerful drawing movements across different media but that the movements

are adapted according to the different possibilities. This means that the drawing movements I have discussed in this chapter are generalised categories. Because people cannot 'see' what children's early drawings are 'about', it is presumed that there is no content at all. But there is, and it is essential to know how to recognise what the drawings are about if we are to provide for and nurture the development of drawing and painting. Early drawings are about shapes; the shapes on the paper and the shapes of the movements which produce them.

SUMMARY

We have seen that children progress from initial exploratory mark-making to powerful marking strategies which partially reflect the natural movements of the body. However, it would be a mistake to think of these actions as just thoughtless, mechanical movements. Children's drawing actions are sensitive to fluctuations in mood, both their own, and those of people around. As the child matures, these actions and shapes are further differentiated and sorted into groups. This is not merely a gradual assembling of a vocabulary of shapes to be used later in the making of designs or pictures, in the way that Kellogg and others describe. Rather, throughout this process, the child imbues drawing actions, and the shapes they make, with emotion and representational possibilities. They are interested in beginnings and ends of lines and map these onto the drawing surface. They attach lines to each other at angles. They colour-code their actions. They also experiment with covering one layer of paint over another. The child represents, on the drawing surface, inside and outside relationships, as well as basic directions of movement, across, round and round, and up and down. Language is involved in this process. They talk about what they are doing and associate the appropriate words with shapes and their relationships. This assists language acquisition, but in turn, language helps guide and organise drawing. These shapes, relationships, and directions of movement serve as the coordinates for later drawing.

5 HOW REALITY TAKES SHAPE

In the last chapter we saw how children develop some powerful drawing rules. In this chapter we will see how children use these rules to make new combinations of shapes. They become interested in colour and shape relationships in themselves, but they also use the effects these produce to work out new ideas about their experience and the world. It seems as if they realise that relationships emerging on the drawing surface are, in some respects, like relationships in the real world. They start to coordinate a family of relationships in such a way that they build up descriptions of reality.

In their drawings we can see children trying to keep the main characteristics of objects as well as how they look from a particular viewpoint. Paradoxically, by using drawing to capture information about the object irrespective of viewpoint, they arrive at possible views of objects. We saw this happen with Joel at the age of two years and eleven months, when he drew people climbing a mountain. Initially, he had played with toy people and a coffee-grinder, moving them around, over and through the grinder. Later he draws these different movements. Figure 5.1 shows going *around* a mountain (upper left); going *over* a

Figure 5.1 Joel, aged two years and eleven months, draws a mountain and climbers

mountain (lower right); and through the mountain by making a hole in the paper (upper left). At this age, the only way he can manage this third dimension is by actually poking the pencil through the paper! (Matthews, 1984) Very young children often investigate 'going-through' by poking holes in their paintings and drawings. Here is an example from observations made of Hannah at the age of three years and five months:

Hannah is making a pencil drawing. The movement of the pencil point becomes the movement of the 'dancer'. She pushes the pencil right through the paper, saying as she does so, 'I danced through the hole and fell through. It has a hole in the other side . . .' She considers for a moment her last statement and then says, bursting with laughter, 'It has to have!'

Children at this time are often interested in many different examples of 'going through': looking through cardboard tubes, telescopes, cameras and any number of items which have holes, meshes, or grids through which can pass light, or sand, or liquid. Drawings and paintings become perforated and used as masks. 'Peepo' games are also popular at this time, as well as picture books which use cut-outs in the pages, for example, the Ahlberg's book which takes its title from the 'Peepo' game (Ahlberg, 1981). Children start to understand about lines of sight and points of view from these investigations and when they play hiding games.

Although the hole in Joel's drawing does not really serve as a true view, the other directions of movement do create true views. Because he traced the climbers' movements around and over the mountain, he arrives at a drawing which shows two possible *views* of the mountain.

KNOWING AND SEEING

The Piaget/Luquet theory of drawing development, at its most simplified, argues that children below seven years of age draw what they 'know' and that only in later childhood can they draw what they 'see'. The former stage was called 'intellectual realism', the latter, 'visual realism'. Although this idea still influences many people's understanding of drawing development, it is very unsatisfactory.

Figures 5.2 and 5.3 show two works, drawn in the same red felt-tip pen which Ben has been using for several days. Both drawings are composed of similar schemas, though they are different in other important respects. For instance, Figure 5.3 has representational values attributed to the lines; whereas Figure 5.2 does not. Also, the way the pen is used differs between the two drawings. It seems as if Ben's production of certain basic structures on the drawing surface has alerted him to the presence of these structures in the world. For several days now Ben has joined lines at right-angles, made parallel groups of lines, closed shapes and varieties of wandering lines (see Figure 5.2). Now that he is producing these forms and relationships on paper he notices new examples of

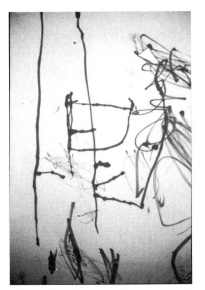

Figure 5.2 Ben, aged three years and two months, explores a two-dimensional structure for its own sake: parallel lines, right-angles, closed shapes and wandering lines

Figure 5.3 Ben aged three years and two months, uses these structures to draw Linda in dungarees

these within the environment. One unusual example of parallel grouped lines is presented in the picture of his mother, Linda, standing near him, in the kitchen, wearing dungarees (see Figure 5.3).

Linda in dungarees

Ben is aged three years and two months, and is sitting at the kitchen table using his favourite red felt-tip pen to draw a picture of Linda on a page of a small notepad. He does not represent her as a tadpole figure, in fact this drawing precedes his first tadpole drawing. He looks back and forth between his drawing and her figure in order to produce this work. Some of the drawing can be accounted for in terms of the structural principles already described. The head or face is an angular closed shape, squeezed in at the top of the drawing surface. Its small size in relation to the rest of the figure is not important to Ben. Just preserving the higher and lower relationship is what is important here. Some people would consider a drawing like this to be simply out of proportion. Such misinterpretations occur because adults do not understand children's priorities about the kind of information to be put into a drawing. This misunderstanding can be very destructive to a child. It is sometimes difficult for people to realise that their assumptions about 'correct' proportion arise from a particular theory about art and representation. Our responses to children arise

directly from our interpretations of what they do, so it is crucial for teaching and childcare that we come to understand the assumptions which lie beneath these interpretations.

Ben may be using the angular closed shape to represent Linda's face, or perhaps the boundary of the volume of her head as a whole. Near the base of the drawing, this topological geometry is used to show the boundary of a hollow space. A pointed ellipse is used to denote Linda's bottom, perhaps meaning anus. He uses the powerful perpendicular junction to create maximum differentiation or contrast between the arms and the body. Single strokes of the pen represent the entire tubular volumes of the arms. Similarly, single pen lines represent entire strips of denim – the straps of her dungarees.

However, it is the denotational values of the lines representing the boundaries of her body which are perhaps more surprising. In a controlled variation of movement along a vertical path, the line on the left actually specifies Linda's breast and waist, whilst the line at the right curves gently from the top of the drawing to form Linda's back, the small of her back and then the back of her thighs. So, he has represented the front and back of a female body. By doing this he has, in effect, also captured a view of her left side.

Observations of Ben drawing, plus the comments he made whilst drawing, suggest that he was representing the outermost boundaries of her body as they curved in and out, down the length of her body from his viewpoint; and around out of his sight from his position at the kitchen table.

DIFFERENT TYPES OF INFORMATION

Ben draws what he knows about the relationship of body parts to each other – what David Marr (1982) calls being 'object-centred' – and in doing so arrives at a possible view of a human figure. Ben quite consciously tries to find out how Linda will appear on paper from a given viewpoint. In looking at her and then drawing the contours of her body as they appear to him from his position at the kitchen table, two metres away, he captures her on paper from that viewpoint.

The two drawings by Ben (see Figures 5.2 and 5.3) use the same shapes, lines and drawing rules. However, the pressure on the pen is different in the drawing of Linda. In addition he is capturing and combining different kinds of information and using them together so that he can create some new representational meanings for lines. In other words, when Ben changes the subject matter he changes the way he organises the shapes and lines he is familiar with to give them different meanings. Although Ben turns out to be an

unusually talented draughtsperson, this occurs with many children. Young children can be 'view specific' (Marr, 1982), for example when Ben looks at and draws Linda from a particular viewpoint; or they can use 'object-centred' information, for example when they draw the main features of something but not as seen from any particular viewpoint.

If a child is producing a range of shapes and other visual structures, then typically he or she will seek out those very shapes and structures from the visible environment. However, this does not mean that children's development in drawing is helped by an overemphasis on drawing directly from observation. Unfortunately, this has occurred in some areas of British art education, and some art advisors have failed to appreciate the importance of the approaches to drawing which children spontaneously generate. These people have tended to think of the drawings and paintings produced by children as limited and limiting stereotypes in which children are trapped and from which they should be rescued. Instead of nourishing and supporting a process akin to language acquisition, the beginnings of drawing have been undermined by a peculiarly limited version of a Western ethnocentric approach to visual representation. This is at its most destructive when all kinds of drawings, not made directly from nature, are prohibited.

Van Sommers (1984, p. 173), in an otherwise important study, mistakenly writes of the 'tyranny' of children's drawing schemata which he feels 'retards' their development. Maureen Cox (1992), like many others, argues that before children can produce creative drawings they need to be purposely trained in representational skills. She confuses representational skills with mere skills in perspective drawing. She argues that the kind of training she proposes is like correcting grammar and spelling. However, she misses out a much more pertinent analogy between language acquisition and drawing development. Both processes are essentially creative in the sense that children, as they mature, are generating language or drawing rules which change as they grow up (Chomsky, 1966; and Willats, 1983). Whilst early drawings, like first sentences, may seem strange, they are the result of powerful and intelligent hypotheses children make about language or drawing rules.

Having representational skills means becoming fluent with a range of techniques with different materials and different approaches to drawing. This entails much more than simply learning how to show adult perspective. Creativity means being able to detect and exploit shapes, lines, spaces on paper and use them for symbolic and expressive opportunities in drawing, painting and constructions of all kinds. This creativity cannot be postponed whilst perspective tricks are mastered. On the contrary it is likely to be destroyed by

such an approach.

Another psychologist, Ellen Winner (1989), writing about a highly prescriptive approach to drawing carried out in some Chinese schools asks: 'How can Chinese children draw so well?' Comparing teaching in different cultures is fraught with difficulties. The evidence strongly suggests that highly repressive, prescriptive teaching methods impair children's ability to respond creatively and to initiate original ideas. The real question to ask is: Why does Ellen Winner think Chinese children draw so well?

The following drawing (see Figure 5.4), like the one of Linda in dungarees, is not in perspective, but similarly captures a range of important information about how things look and how things are.

Spilling milk; face-on views of faces; edge-on views of beans on toast

In this drawing, Ben, aged three years and two months, depicts himself as a tadpole figure, yet it comes later than the drawing of Linda in dungarees. The tadpole form is perfectly sufficient for this drawing which is about himself spilling a glass of milk (see Figure 5.4). We can see the glass at the moment

Figure 5.4 Ben, aged three years and
two months, holds a slice of beans on
toast but drops a glass of milk

when it falls from his arm and the droplets of milk fall through space. Since children during this phase are interested in how things connect, it follows that they are interested in the opposite of this – how things become disconnected or fall apart.

In the drawing, Ben is holding a slice of beans on toast in his other hand. Ben has realised the potential of closed shapes to represent face-on views of faces (faces of people and other objects too) and the potential of single lines to represent foreshortened planes. Perhaps he arrived at a foreshortened view of the beans on toast because of trying to show that the beans were 'on top of' the toast. Other shapes, for example, a square with dots for beans placed inside it, may not have conveyed this information.

We glimpsed beginnings of this ability to rotate events and objects through ninety degrees in drawings made at an earlier age. For example, in a drawing by Hannah, she showed the rain coming down as sheets of water through a vertical plane, and individual drops colliding with the ground at right-angles. It might be the ability of children to imagine directions of movement which makes possible a later understanding of directions of view.

The basis of this understanding can be found in children's play. From the age of one, Hannah, Ben and Joel enjoyed all kinds of twirlings and spinnings. You will remember the example of Hannah's continuous rotations. All three children also played with opening and closing doors. Sometimes the way they varied the moment-of-turn signified important events in their pretend play with toys. At other times, Joel and Hannah pretended that they themselves were doors, opening and closing by slowly turning on the spot with arms outstretched. Sometimes adults were not allowed to pass by them without 'opening them', perhaps by pressing an imaginary switch.

Drawings like the one shown in Figure 5.4 contradict Piaget's verdict of the way very young children understand and draw perspective. He thought that children under the age of four showed 'a complete lack of understanding of any sort of pictorial perspective' (Piaget and Inhelder, 1956, p. 173). His experiments showed children failing to represent foreshortened disks as single lines, and foreshortened sticks as dots, but persisting in representing these things as circles or lines respectively. He concluded that children had no conscious appreciation of their own viewpoint.

However, more recent research by John Willats has suggested that the problems which beset children when they draw foreshortened sticks and disks do not derive from a failure to realise they have a viewpoint, but in the particular constraints presented by drawing (Willats, 1992).

Views, Sections and Surfaces

Children draw houses or people on a line representing the ground in ways which suggest at least the beginning of projective representation, or perspective

(see Figure 5.5). In Figure 5.5 Ben shows 'cars on a road'. In another picture (see Figure 5.6) he shows a table with objects on it, showing an edge-on or

Figure 5.5 'Cars on a road' by Ben aged three years and three months

Figure 5.6 'Objects on a table', by Ben aged three years and three months

foreshortened view of a table. This is clearly a development of the thinking involved in his drawing of beans resting on top of toast.

There are other possibilities too. Look at Figure 5.7 which shows 'A man digging in the ground for the bones of animals'. Does the line of the ground show a *section* through the ground? Or is he using this line to show 'under' the ground? He showed the on-top-of relation by placing beans on the line representing the toast. As in the 'beans on toast' drawing, he is arriving at a representation of a foreshortened plane. This ground line is a view which he has to imagine – a sectional view. Ben is therefore doing more than showing 'on top' and 'underneath' relationships. In Figure 6.11 (p. 76) he has drawn a

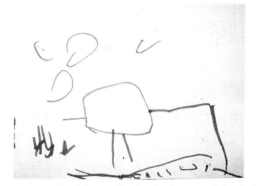

Figure 5.7 'A man digging in the ground for the bones of animals', by Ben aged three years and three months

foreshortened view of the reindeers' antlers and has shown the gracefully curving shapes of the antlers. This is all the more convincing if we look at another drawing he made of antlers shown in Figure 5.8. Here he has captured

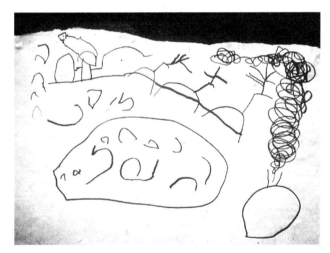

Figure 5.8 'Father Christmas on his sleigh with Reindeer', by Ben aged three years and three months. Letter shapes are contained within the closed shape

another, very different but equally true feature of antlers, their prong-like aspect.

Young children often try to show several things at once. For example, often when they draw hands they show them to be either prong-like or slab-like, or they combine both these characteristics (Willats, 1992).

Summary

In this chapter we have seen how children capture different types of information in their drawings. One type of information contained in their drawings concerns the main characteristics of objects irrespective of any fixed view-point. Another type of information is the shape of the object as seen from a particular viewpoint. Children combine these and other kinds of knowledge in their drawings right from the beginning. They are sorting out what the lines and shapes stand for in the real world. We also saw that the meanings of the lines, and the way in which they are drawn, varies with context. An important point has been that the act of drawing guides children's observation of the environment. This means that children start to notice in the real world, shapes which may first appear on the drawing surface. This is important because it means that children are able to draw from observation only insofar as the shapes they see in the real world are, in some ways, like the shapes in their drawings. The teaching implication of this is that simply forcing children to draw from life will not in itself speed up development – probably the reverse.

Different influences lead Ben towards projective relationships and the beginnings of perspective in his drawings, so that he does not just use topological relationships. One way children move towards using perspective as they draw is through their symbolic play and their movement through three dimensions of space and the dimension of time. To show a view of something on paper is as much to do with showing a particular moment in the flow of time as it is with drawing the object itself. The child in imaginary play constructs imaginary universes in which he or she moves through a variety of directions of movement, and rotates handheld toys through a range of orientations building up an understanding of what might be seen from different positions. How the child develops representations of events and objects in time and space is the subject of the next chapter.

6 SPACE AND TIME

Space and time are aspects of the same reality. One of children's concerns in representation seems to be the coordination of these two aspects. In their play, painting and drawing, children make patterned sequences of movement which they realise share characteristics with patterns of movement they see in the outside world.

Children attend to a wide variety of unfolding phenomena. As we have seen, they think about highly visible catastrophic events such as milk spilling and aeroplanes crashing. They also think about and represent subtle events like sitting, or invisible events, such as music going through a trumpet (see Figure 7.1 on p. 89). They record these phenomena in their drawings and in symbolic play. They also represent more complex events which interest them, such as clouds moving and the rain coming down. We have seen how children's interest in changes of position and state often alternate with each other in quick succession. A good example of this is a series of paintings in black oil paint on paper which Ben produced at the age of three years and one month. Here we can see him moving in and out of a range of representational concerns, sometimes within a single painting.

In the first of the series, he paints a portrait of me, in tadpole form, in which those familiar paired parallel lines represent my legs (see Figure 6.1). Feet are

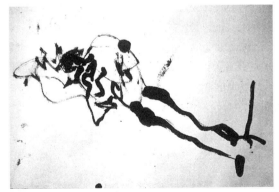

Figure 6.1 Ben aged three years and one month, paints a tadpole figure

differentiated from the legs by marks attached at approximate right-angles. The facial features are upside down with respect to the rest of the drawing. This tadpole figure shows the configurative aspect of representation – it is concerned with the shape of a person.

The next painting in the series is, he says, about 'someone washing' and starts off with a configurative representation at the bottom left, the shape of a water tap (see Figure 6.2). Perhaps he thought directly about the visual form of the

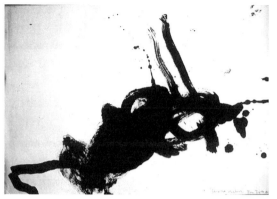

Figure 6.2 'Someone washing', says Ben about his next painting

tap, or perhaps he arrived at this shape by thinking about the action of the water running through it. Further to the right he changes to a quite different way of representation. A circular motion of the brush in a pool of paint shows the actions of 'someone washing'. This then is a movement, a dynamic representation. Further to the right he returns to a configurative representation when he runs those parallel grouped lines down into the pool of paint to show someone's arms reaching into the washbasin. Ben alternates between configurative, and dynamic ways of representation within a single painting.

The third painting (see Figure 6.3) is of a helicopter. Who can say whether this represents the shape of the helicopter, or perhaps the dynamic action of its rotor

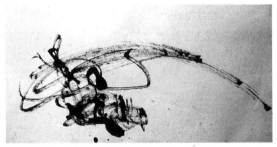

Figure 6.3 'A helicopter' by Ben, the third painting in the series

blades? Or, perhaps in describing the action of the helicopter he arrives at something to do with its shape. This is part of the way painting and drawing work – not by somehow copying the world, but by generating a world within

the act of painting itself.

In the last of the series (see Figure 6.4) he seems to relax momentarily from the struggle to play freely with shapes on paper. New forms made in this free

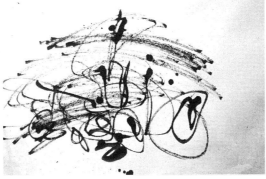

Figure 6.4 In the last of this series of four paintings, Ben free plays with shapes and lines

play will be carried back into his next attempts at representing the world. Dennie Wolf (1984) has described how play and less playful ways of drawing flow into and nourish each other.

Ben is engaged in an ongoing conversation, in which marks and shapes appearing on the paper encourage him to think in certain ways about their relationships. Painting episodes can be likened to a journey into an everchanging landscape in which, at every twist and turn, new vistas of possibilities emerge. From moment to moment, the marks on the paper prompt representational possibilities which the child pursues, but which are later overtaken by other possibilities suggested by newly appearing shapes and colours.

There are important implications here about visual and linguistic narrative. Telling stories in pictures appears throughout the history of art. Shortly we will see how Ben develops this in a series of drawings made over the next few months. This dialogue not only involves Ben's drawing, but his whole reality becomes the currency of this continuous fluid exchange. If we look at Ben's construction with blocks and Lego in the miniaturised world of symbolic play we see him progressing from dynamic play (representing movement) to the configurative use of his schemas, in which the shapes of things are represented. We see both the dynamic and configurative aspects of his schemas.

The floor is strewn with wooden blocks and Lego, toy cars, toy people and drawing materials. At first glance it looks chaotic, but in fact there is an 'arrangement' which changes over the days. Ben is interested in fire at this time.

Figure 6.5 Ben, aged three years and two months, draws a car bursting into flames

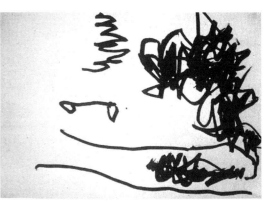

Figure 6.6 Fire goes through two parallel lines representing a spacecraft. Above it is his initial letter – 'B'. The zig-zag is 'writing' describing the drawing

Sometimes there are fierce conflagrations and cars burst into flames (see Figure 6.5), or spacecraft take off (see Figure 6.6). Here he draws fire going through two parallel lines representing a spacecraft. Above it is his initial letter 'B'. The zig-zag is 'writing' describing the drawing. Sometimes on a less dramatic scale there is smoke going through a chimney. It is Autumn and bonfires have appeared in the neighbourhood. Ben is only three years and three months, so during the previous Autumn he may have been too young to notice fires. There may be a second level of symbolic meaning here. His themes of play at this time seem to revolve around the transmission and control of energy. This might, for a three-year-old, make fire a highly salient image.

THREE-DIMENSIONAL CONSTRUCTIONS, SCULPTURE AND INSTALLATIONS: THE RELATIONSHIP TO TWO-DIMENSIONAL WORK

One day, Ben gathers up armfuls of coloured plastic straws (actually a construction kit) and repeatedly throws them up in the air making fire noises. He is representing the dynamic, moving aspect of the fire, the movement and the sound of brightly coloured flames. Over a period of ten days he gradually introduces other objects to this heap of toys, including pieces of Lego and wooden blocks (see Figures 6.7 and 6.8).

'Heaping' objects is often the first way children classify objects (Athey, 1990), and Ben's use of the heap as a fire, originates from this level. He continues to jumble up this collection into a constantly moving heap, to represent the

Figure 6.7 An early stage of a 'fire' built by Ben, aged three years and three months

Figure 6.8 The fire at a later stage, by Ben, aged three years and three months

constant motion of the fire. The 'fire' goes through a series of transformations during this period, as different elements are added or subtracted. At one time he uses a sleeping bag (see Figure 6.7) which he has dragged into the room. This acts as a demarcated area for the fire. Gradually, his movement of the blocks becomes less. There is less jumbling and tumbling, more careful adjustment of pieces until eventually Ben is modifying this heap of blocks, Lego and few remaining plastic straws, as if it is a piece of sculpture.

Whilst the fire moves through these continuous transformations, one thing in this play scenario does not change. Apart from a little daily variation, a line of cars and characters including a cowboy, Donald Duck, a plastic bear with a light 'rose' for a hat, and 'Squeaky Man' – a soft plastic toy who squeaks when you press him – all queue up to watch the fire. This line of toys radiates outwards from the fire which is the central pivot to the play. The whole structure recalls the drawn core and radial schema. During the last phase of this play, Ben makes carefully formed towers of blocks and Lego to represent, not buildings, but tongues of flame (see Figure 6.9).

Figure 6.9 The fire, by Ben, aged three years and three months

It is the fact that this sculpture represents something so ephemeral as a fire which makes it especially interesting, although it would still have been impressive as a building on fire. Ben has used three-dimensional materials in a similar way to his use of two-dimensional media. He has been concerned both with the dynamic and configurative aspects of fire, with both aspects of schemas. Over a period of ten days, in a free-flow interaction between play with the materials and construction (Bruce, 1991), he has moved from a representation which captures the movement of the fire in time, to a representation which captures its form in space. The dynamic aspect of the schemas has guided and enriched the configurative aspects. In some ways, Ben's thinking is like that of a creative adult thinker or artist, starting with a hazy, germinal sketch and moving through variations and possibilities to its ultimate realisation in more concrete terms, which incorporates all the main features about which the thinker has been concerned.

There are some important teaching implications to be noted here. The objects he has used have not always been used for the purposes for which they were designed. Construction straws have indeed been used for constructing but not the kind of construction for which they were intended. Different sets of objects have been mixed together. Household objects, including a mirror, a sleeping bag, a light 'rose', have been mingled with manufactured toys, and have in fact been transformed into toys. On another occasion, he found a book on space travel in which there was a photograph of a rocket taking off, with jets of flame shooting from its combustion chamber. He opened the book up at this page and laid it on the floor. He then built onto the two-dimensional image of the flames a formation of blocks which again represented flames but in three-dimensions (see Figure 6.10).

Figure 6.10 Three-dimensional flames are combined with two-dimensional flames using blocks and a picture in a book, by Ben, aged three years and three months

This combination of two-dimensions with three-dimensions is Ben's own stretching of the boundaries and conventions of representational systems. This kind of thinking would not be possible if adults had decided beforehand how the toys and books should be classified and used. Linda and I made no restriction on his use of media based on a prior classification of our own. We did not interfere with his combination of objects. Drawing materials have also been mixed in with his other toys. Every so often, he would stop building and draw. There was an interaction between his thinking in two-dimensions and his thinking in three-dimensions. More fundamental still is that, at this level, Ben's thinking is embedded in actions he performs on these objects of play. To tidy up these objects each day would have been to totally disrupt his flow of thinking. Linda and I cleared up around the sculpture, allowing the central formation to remain.

The difficulties in allowing for this development in the classroom are not insurmountable. It is possible for the teacher to make a drawing of such a sculpture and to re-build it later from this plan (Gura (ed.), 1992). Or polaroid photographs or video-recordings can be made as plans for re-building. Young children are intrigued by the fact that their work can be recorded in various forms and this in itself offers interesting teaching possibilities. This approach can also form part of evaluation and pupil-profiling (Bartholomew and Bruce, 1993).

Before we move on, one other point should be made. Provision for block play is often based on the assumption that it is a communal activity. Frequently, completely individual, personal construction is subjected to upheaval and destruction because of this approach to provision (Gura (ed.), 1992).

SHOWING MORE COMPLEX EVENTS IN SPACE AND TIME

Here we will look at relations between and within objects and events as can be seen in a drawing by Ben at age three years and three months (see Figure 6.11, overleaf). As always, my analysis is derived from what Ben actually told me about his drawing. It shows Father Christmas arriving on top of a house. He is shown in two positions in time and space. The house is represented by a closed shape. Ben has differentiated higher and lower relationships in the closed shape. A horizontal line subdivides it, representing the upper floor. (Ben has for several weeks been showing higher and lower relations on the drawing surface – one example being his drawing of a train which, he said, went 'over' and 'crashed

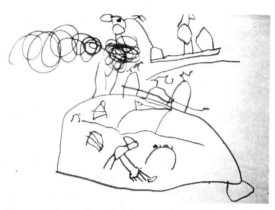

Figure 6.11 Father Christmas arrives on a house-top and goes down the chimney, by Ben aged three years and three months

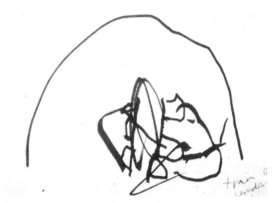

Figure 6.12 'The train crashed "under" the bridge' ,by Ben aged three years and three months

under the railway bridge' as shown in Figure 6.12.) The marking of higher and lower relations develops until it becomes a true vertical axis.

This seems to be happening in Ben's drawing of the house with its 'upstairs' and 'downstairs', and the fireplaces on the lower and upper floors being vertically in line with the chimney. Perhaps he is showing a cross-section or a totally foreshortened view of the upper floor. Remember my comments about foreshortened planes and sections, for example, in the drawing of the 'man digging in the ground for the bones of animals' (see Figure 5.7, on p. 67). We have already mentioned possible 'edge-on' views of the table upon which objects rest (see Figure 5.6).

Ben adds more information to his topological geometry

Ben has not been concerned with showing true angles in the boundaries of the house or in the corners of the table. We could look at Ben's drawing in terms of deficits but that would be to go against the principles of early childhood education (Bruce, 1987) and to begin with what Ben cannot do rather than what he can do. Such a negative approach would show that Ben has failed to preserve the rectangularity of a 'real' house and of a 'real' table. Adults working with deficit theory approaches might want to point out to a child the right-angles in the 'carpentered environment', as in windows, doors and tables with the aim of correcting these so-called 'errors'. However, this would be to totally misconstrue the way Ben is making his representations. His concern is to represent the house as a volume which encloses people and furniture. To this

basic topological geometry he has added higher and lower relations to show that objects rest on tables, and the vertical linear relationship of the chimney and fireplaces allows Father Christmas to descend.

It is later on that he will use controlled angular variation or 'moments-of-turn' in line junctions, when he feels it important to preserve the angular variation in, for example, the depiction of corners, and when he realises the significance of angular variation in letter and number forms. These Euclidean properties are not generally present in the drawing under discussion, and when they do occur they are not adequately explained in the usual terms of this system of rigid geometry. For example, when Ben does draw right-angular line junctions, he does not use these to show corners of a table or other rectangular features but to show something far more significant to him – an invisible action. Near the bottom of the drawing in question Linda is vacuuming the floor. A small piece of paper is about to be sucked up into the vacuum cleaner. It seems possible that Ben uses the parallel grouped lines at the base of the vacuum cleaner to represent suction.

Going through a bound volume

Ben represents another movement through a tube: Father Christmas's entry and descent through a chimney. Ben is thinking of the different positions in both space and time. We can see Father Christmas in position 1, on his sleigh and, a moment later, in position 2, about to descend the chimney. We need to remember that we are looking at just one Father Christmas and not two. He is being shown at two different moments in time as well as space. So this drawing is very complex in terms of Ben's understanding and organisation of events and objects occurring within space and time. He has obviously thought about the actual house in which he hopes this event will take place, and has found out something about its geometry. When he plays the adventures of Father Christmas – his journey through the sky onto the roof and his descent through the chimney – this helps him build up and coordinate the understandings of time and space which make this drawing possible. We saw emergent aspects of this earlier on in the book (see Figure 4.2 on p. 46) in the way children are fascinated with the beginnings and endings in time and space. When children make dots and blobs in a line, or hop in a game like hopscotch, or pretend to be rabbits hopping (Wolf, 1983; and Gura (ed.), 1992) or hold miniature people and jump them up and down along a line to represent their footsteps, they are showing sequences in time and space with actions and objects.

Movement and time: changes of state and changes of position

This concern with the passing of time in space is re-explored all over again at different moments in the child's life. A good example of this is Ben's 'King and Castle' series. In the drawings which he says are about 'a king falling off a castle' (see Figure 6.13), the unfortunate man topples from the top of the castle,

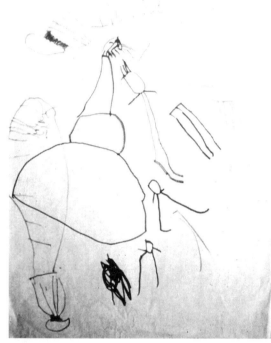

Figure 6.13 'The king falls off a castle'. Ben, aged three years and three months

Figure 6.14 'The king walks up a hill and catches a flying kite', by Ben aged three years and three months

falling in stages until his impact with the ground is marked with a dynamic squiggle of the pen. As he falls, he loses his crown on the way. Ben is clearly trying to coordinate and represent the flight paths or trajectories of two objects which start off their descents together but then follow separate destinies.

As the days pass, Ben continues to think about the king's movements. On another day, for example, the king goes for a walk up the hill and retrieves a flying kite (see Figure 6.14). This is almost the reverse condition, in which two separate trajectories converge. On another day the king jumps off the castle and goes for a walk. This is one of the recurring themes of his play and drawings during these weeks. The drawings were in fact stimulated by a toy he had at this time which consisted of a set of plastic cups graded in size so that the entire

set could either be nested concentrically within the largest or, with the largest inverted and forming a base, the other cups could be placed rim down on each other from bigger to smaller to form a tower. The final and smallest item, which could either be contained at the centre of the concentrically nested cups, or go on top of the tower, was a small plastic tube closed at both ends and embossed with a face and a crown – the king. In play, Ben would use this handheld king to act out various flight paths. He also used his other tower, built with wooden blocks. A range of different types of trajectory were investigated with handheld toy figures around these towers. These imaginative play scenarios would flow back and forth between the two-dimensional environment of the drawing surface and the three-dimensional world of his pretend play (Bruce, 1991).

Sequences of events: visual narrative

An interesting drawing made by Ben at the age of three years and three months (see Figure 6.15) shows his journey from nursery school to his house. Ben's

Figure 6.15 The journey from nursery school to home by Ben, aged three years and three months

concern to mark the beginning and end of a linear route has been shifted here to a new level in his thinking. At the right-hand end of the line, a small closure represents the nursery school. We travel along this line, which represents a road, to position 1, where Ben and Linda's standing figures are depicted, together with the pram which contains his baby brother Joel. We continue along the road to the left, crossing the railway line, up a very steep hill, past the road which leads to the nurses' flats, to where the people and the pram are shown in position 2. From there we travel to the end of the line, where our house is demarcated.

Everything drawn showing the sequence of his route is correct. Ben also

shows knowledge of the relationship of this route to others. The railway line over which the road crosses is part of the route from London to Liverpool to see his grandparents. Around this time Ben was producing map-like drawings of this journey. Thus, the drawing has geographic as well as narrative aspects.

A few days later he produces a drawing which shows a flying boat taking off out of water (see Figure 6.16). A line shows the surface of the water. Ben might

Figure 6.16 At three years and three months, Ben draws a flying boat moving through four positions in time and space

want to show the boundary between the surface of water and medium of air. The closed shape drawn above this line represents a boat (perhaps shown in section) taking off out of the water and flying into the air. Ben has repeated the image four times on the same sheet of paper to show it moving through positions 1 to 4. 'It takes time,' is his explanation to me for drawing four images of the same object. From the base of each of the four drawings of the same boat, are those roughly parallel grouped lines like the ones we saw when he showed paper being sucked into the vacuum cleaner. In this drawing they represent streams of water trailing off as this mysterious sailing boat ascends.

Coordinating horizontals and verticals

Interestingly, in position 4, to the furthest right-hand side of the drawing surface, the boat has been rotated through ninety degrees so that the trails of water (grouped parallels) run out horizontally and stop in a right-angular

junction with the last vertical line of the preceding boat's water trails.

There are various possible interpretations of this part of the drawing. Piaget and Inhelder (1956) would say Ben cannot show different parts of the drawing in a coordinated way – he cannot fit everything into a Euclidean coordinate system of horizontals and verticals. In their studies they showed children line drawings of upright and tilted containers and studied how they drew the water-level inside these drawings of containers. They also studied how the children aligned trees on the side of a drawn outline of a hillside. A more recent study by Bremner (1985) suggests that young children may understand horizontals and verticals in the real world, but have difficulty drawing these due to the powerful visual effects of lines and line junctions which arise during the drawing process. However, none of these studies is about children's spontaneous drawing, so they are not sufficient as explanations for real-life situations. They do not sufficiently address the issues which Willats' work (1992) has highlighted, namely the constraints of the drawing medium. They involve either adding something to someone else's drawing, or copying a drawing. They do not help us to understand the decisions about visual structure which children are making from moment to moment in free-flowing play with the drawing medium (Bruce, 1991).

It is consistent with this way of thinking that Ben does not consider the finished drawing as a whole or from a single view-point. Since the water has to fall from the bottom of the boat, then this remains the rule for boat position 4 – even though this is turned on its side. This might be the result of the object-centred type of information we mentioned earlier and it might also implicate language, that is verbal descriptions of objects which include terms like 'top' and 'bottom'. Or perhaps Ben is showing how trails of water might be left behind in space as the boat turns on its side and flies off at speed. It may be that during his play in the bath, Ben learnt about water-lines and how water drips or pours from handheld boats flying in space.

Children learn from other people's pictures

Another influence upon this and other serialised images he drew was the comic books he avidly studied at this time. In particular, he was interested in the 'Rupert' picture story books. In one of these adventures, the artist, Alfred Bestall, illustrates in a sequence of stills a special boat taking off from a lake. Water does indeed trail off from the bottom of the boat. However, these pictures of a sailing yacht differ fundamentally from the ones produced by Ben. Ben did not 'copy' these pictures. His developing schemas acted like internal software or

templates through which Bestall's drawings were filtered. We shall return to this important point again as it will help to understand the processes involved when children are taught or influenced.

Talking to children about how pictures work

From about the age of one Ben enjoyed looking at picture stories with me. At around two-and-a-half years of age he was clearly trying to work out the conventions of the serialised-image mode. He would ask questions like, 'Why is there more than one Rupert?' I would explain that there was really only one Rupert but the first picture showed Rupert setting off from his mummy and daddy's house and the next picture showed him a little later on when he had reached the forest.

Ben was extremely interested in these explanations. The conversations formed part of a very important interaction between Ben, myself and Linda in which we discussed how pictures worked, both his own and those of other people. This helped him to talk about his own ways of drawing. It helped him to gain more control and freedom in his drawing since he was being helped to think about how his drawings worked. The unfolding nature of children's drawing development, whilst self-generated, does require a special kind of interaction with other people as well as provision of materials if it is to fully flourish. This interaction includes pictures by other artists and discussions about how these work. As Ben grows older, further conversations with him about his own pictures and those of other artists help him to develop his techniques in drawing and painting.

Many different pictures from a few drawing rules

Changes of states and changes of position seem to be the deep structures – the different aspects of schemas – underlying much of Ben's drawing at this time. He draws and paints with great enthusiasm, the shape of events as well as the shape of objects. His drawings of serialised images are interspersed with other fascinating drawings of a wide range of subject matter. Yet, in formal terms, he has at his disposal a quite limited vocabulary of drawing devices. He is able to employ his same small repertoire of lines and shapes by making subtle modifications depending on what he is drawing. Again, this underlines how important it is, when considering how a drawing is made, to also consider the content, because these interact together. What Ben draws will affect how he uses the rules he knows about drawing.

The drawing shown in Figure 6.17 is by Ben aged three years and three months. It is a representation of an astronaut's footprint on the Moon. At the bottom of the drawing, a figure looks up through a transparent dome at this image of the boot's tread. He saw the famous photograph of the first person's footprint on another world in a space-travel book in a public library. He was immediately struck by this powerful image. 'What's that?' he asked me. He recognised it readily enough when I explained it was a footprint. He asked further questions and I tried my best to explain. This involved concepts which were quite difficult for an adult, let alone a three year old to comprehend. Ben knew about footprints, and he also knew about the Moon. How could a footprint get on the Moon? The other photographs in the book showed the astronauts themselves, walking on the Moon's dust. Perhaps to a three-year-old, these figures, transformed by their white space-suits, do not look like humans at all. When Ben made the drawing at home, he said that it was a 'footprint of a monster on the Moon'.

Figure 6.17 'Footprint on the moon', by Ben aged three years and three months

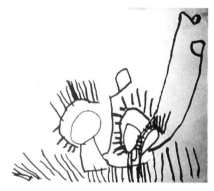

Figure 6.18 'Red indians in the long grass with flags', by Ben aged three years and three months

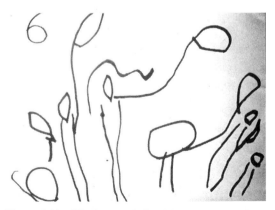

Figure 6.19 'Six boys with flags', by Ben aged three years and three months

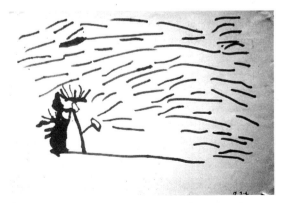

Figure 6.20 'Red indian chief shooting lots of arrows', by Ben aged three years and three months

Over a period of a few weeks from the age of three years and two months, when he drew the drawing of Linda in her dungarees, and three years and five months, Ben produced a profusion of fascinating drawings including for example, 'Red indians in the long grass with flags' (see Figure 6.18); 'Six boys with flags' (see Figure 6.19); and 'A red indian chief shooting lots of arrows' (see Figure 6.20). It is remarkable that all of these drawings are composed using the same drawing rules described above. These are:

- closure;

- variations on right-angular joints;

- core and radial units;

- U-shape on baseline;

- parallel grouped lines;

- zig-zags, waves and loops;

- energetic squiggles.

This is the sum total of the shapes and lines he possesses. The same ones are used by most three and four year olds. What makes Ben's drawings unusual is the way he varies, modifies and combines these forms. It is the imaginative way he brings them together which gives the drawings their power and seemingly endless permutations.

Wittgenstein (1973) believed that the meaning of the word was in the language. In Ben's drawing, the meaning of the lines and how they are produced, in terms of variations of pressure, speed and intensity, changes drastically according to context. **Closed shapes** have been used for a variety of faces, both of objects and people, or to convey volumetric solids in their entirety. **Single lines** have stood for boundaries of volumes, or as cracks, wires, straps, streams of water or as tubular volumes, like arms. They have also been used to suggest imaginary lines like water-lines and sections through the ground. By varying **parallel grouped lines** just slightly or joining them at varying **angles to a baseline**, they have been used to represent the legs of animals or people, points of crowns, straps of dungarees. They have been used to represent the boundaries of tubular volumes like trumpets and chimneys. They have also been used to represent the very different observed boundaries which form a woman's body. They have been used to denote the tread mark of an astronaut's

boot, native American indian headdresses, long grass, even the flow of water and air. This list is by no means exhaustive.

The uses and variations of **right-angles** are numerous. It is an extremely effective way of creating differences and contrast between shapes. There is a special kind of right-angle used in the core and radial unit. Using this form, children are able to show the relationship between roundish volumes and long, tubular or stick-like ones. The tadpole figure and the Sun are only two of the many examples of this relationship. Water dripping from flying boats is a more unusual example. Another variation of right-angular attachment is the **U-shape on baseline**. Like basic closed shapes, they can be used to contain other elements, such as a house which contains people. By joining such U-shapes together in various ways one can generate a range of cell-like units. U-shapes

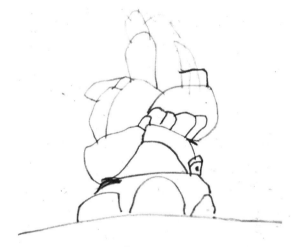

Figure 6.21 'A house', by Ben aged three years and
three months

can be clustered together to form complex houses or vehicles (see Figure 6.21) or placed on top of each other to form towers off which kings can topple.

Ben has an ability which he shares with some, but not all, very young draughtspersons. He can approach the same or similar forms with a variety of strategies. He has plenty of choice about how to go about drawing something. One example is the various ways he can make closures and add them together, either by using the basic closed shape, or by using a U-shape on baseline, or a travelling loop, like an elegant 'e' or '6'. Each of these is slightly different but they can all be used to arrive at a similar end. It is this ability to make controlled variations as he draws lines, which helps him to capture the smoothly undulating forms of reindeers' antlers as well as their spikiness.

Education and childcare: what we can do to help

Because Ben had a natural inclination to draw and paint should not be taken to mean that other children cannot achieve a similar fluency in drawing and painting. Just as important as naturally inherited traits, or parents who draw and paint, is the quality of interaction between caregiver and child. Linda and I tried to talk intelligently with Ben about how his drawing worked. What is required is an interest and understanding of child development and an interest in the arts. It is far more important as a caregiver to have an understanding of how art processes might promote development in a child than to possess artistic skills oneself. Linda and I did what other people can do – create a field of discourse, an area of shared understanding about form, shape, colour and meaning, which permeated all our actions and conversations.

My experience of working and playing with children other than my own, in London and Singapore nursery classes, is that they are often delighted to find that it is actually possible to talk about drawings in a serious way, which goes beyond the 'very nice' response. It is possible to interact with children in a way which will help them understand at a more conscious level how forms interact to create meaning. In order to achieve this, it is necessary that teachers, parents and other caregivers have knowledge about what is available within a human discipline (be it mathematics, language or art) and how this interacts with processes of human development. With this approach it is quite possible for teachers and parents to create environments in which both children and adults are immersed in ideas about structure, form and content; environments where it is understood and accepted that one has the freedom and the right to experiment with relationships of shape, form and colour as signifiers of meaning and emotion.

It is certainly not the case that, as far as drawing and painting are concerned, 'one either has it or one hasn't'. There are ways to help enrich most children's abilities to formulate and manipulate images, and they need not be very complicated. Take what appears to be a fairly trivial response by an adult to a child drawing: 'That's a very exciting zig-zag line, Jason.' While this might sound banal, the teacher has communicated to the child:

- an interest in what he is drawing;
- a descriptive term for the type or class of line he has drawn; and
- an additional noun-qualifier which shows the child that this particular zig-zag line has the power to excite.

This means that the child is being introduced not only to the idea that lines and marks belong to geometrical, mathematical classes but (as Nick McAdoo has pointed out to me in conversation) in addition they have expressive attributes, which cannot be mathematically described but which belong to the realm of aesthetics.

The problem for teachers and other adults is not one of just learning what to say, but of learning to see – and of seeing without prejudice. Developmental theory helps. Once you can see, you will know what to say. It is not even the case that one always has to say something. Burying children with words is the very last thing one should do (Bruce, 1992). If the teacher has allowed the children to understand the way he or she thinks about form, shape, colour, line and action, then sometimes an encouraging sound or gesture is sufficient, for this will convey a wealth of shared understandings. There really are no absolute rules here, and this is a fact of life that many find hard to understand. Sometimes it is necessary to pretend that one is not interested in a particular child's drawing because one knows that the slightest show of interest is likely to disrupt the child. In such cases, of course, it is still necessary to observe and record. It depends on the relationship of trust and understanding which has developed between children and teacher. The best teachers relate to very young children as fellow learners. To use a phrase used by Geva Blenkin in our conversations, a teacher is 'a more experienced learner'. They are children's companions on an intellectual adventure.

Another way for adults to interact with children as they draw and paint is to be practically involved in painting and drawing too. However, there is an inherent danger in this advice – it is often the adults who are the most rigid and limited in their understanding of the arts who are (paradoxically) the ones who practise the most 'hands-on' type of interaction, manipulating and interfering with the children's work to an overwhelming extent; sticking things on it, cutting it up, repainting it and generally communicating to the child that his or her efforts are inadequate. Such teachers often adopt a highly prescriptive approach, with a fixed end in mind (and often of the most banal kind). Bruce (1991) calls this the 'screwed up tissue paper syndrome'. With these methods, children are reduced to slaves in a 'cottage-industry' production line, mass-producing stereotyped trivia. This completely cuts across vital processes of symbol formation within the children. It is highly likely that the English National Curriculum in Art will tend to exacerbate the problem, though this replaces Christmas angels and Mother's Day cards with 'basic art elements' and 'direct experience' (still-life drawing). These and other components are similarly bolted together in an arbitrary way (Matthews, 1993). This

type of approach has nothing whatsoever to do with the interaction I am advocating.

SUMMARY

From three years and two months of age, Ben modifies and adapts a small number of shapes and lines in order to coordinate complex relationships in space and time in his pictures.

Like most other children he uses systems which allow him to represent the structure within and between objects, as well as their movement. He plays with blocks and Lego and this helps him think about, and represent, the dynamic and configurative aspects of objects and events – their movement and their shape. He subdivides closed shapes to show higher and lower relationships. He shows directions and successive stages of movement across, up, down, in space and time, or sometimes through a bound volume (such as a chimney). He shows on-top-of relationships and creates foreshortened or 'edge-on' views of objects (such as tables of antlers). This means that he is starting to organise representations of objects and their movements within three dimensions of space, plus the dimension of time.

Again, language acquisition is involved. The pictures were accompanied by Ben's spoken narrative. Language helped organise the drawing, but in turn, the drawing was extending his language. There were also geographic and mathematical aspects to his drawing and construction.

He uses only a small number of drawing 'rules' to create such a wide range of representations. These rules are available to most young children. It may be that the supporting social setting helped Ben elaborate these rules. Linda and I talked to Ben about how the drawings worked and how other kinds of pictures and picture stories worked. This may have helped him see the various ways the rules might be applied, and the various ways shapes could be combined to make new meaning.

During this prolific period of drawing, Ben generates images in which the lines and shapes stand for objects and events in the world. These lines and shapes transform the real world into shapes on the surface of a sheet of paper. However, they do not all do this in the same way. As we have seen, some visual processes represent the *shapes* of objects, some record the *shapes* of events. In the next chapter I shall discuss yet another kind of image he produces on the drawing surface, in which objects and events are represented, not in terms of their shape, but in quite a different way.

7 THE ORIGIN OF LITERACY: HOW VERY YOUNG CHILDREN LEARN TO 'READ'

We have seen Ben start to produce shapes on paper which define the shapes of objects. We have also seen children use drawing to represent the movements of objects. Another kind of action is also represented in drawing. Very young children start to realise that they can represent, with their own marks on paper, the sounds of their own voices and the speech of others. We have seen some examples of this already, where Hannah counted her own drawing actions or made vocalisations in time with her drawing movements; or when Ben drew music going through a trumpet (see Figure 7.1). Very young children look for

Figure 7.1 *'Music going through a trumpet', by Ben aged three years and three months*

the deep structures which persist despite changes in surface appearance; and if Father Christmas can go *through* a chimney, then music can go *through* a trumpet.

Another example is when Hannah, aged two years and two months, starts a drawing game with me in which she synchronises her own speech sounds, 'Baa-baa-baa', with intense horizontal arcing motions, moving from side to side using a felt-tip pen. Analysis of the slow-motion video recording shows each mouth-opening 'Baa' to coincide almost precisely with the arcing strokes of the pen. It therefore seems likely that each arcing stroke represents each 'Baa'. What qualities do the vocalisations and the drawn horizontal arc share? Is she recording or 'writing down' each 'Baa' sound?

She then requests me to join in and, after I make the sounds, 'Baa-baa-baa', she makes three fanning movements of the pen. This is repeated several times, with Hannah maintaining a perfectly timed, rhythmic game of patterned interaction. It is almost as if she is writing down the words I am dictating.

B IS BEN

In Figure 7.2 we can see images which, though made out of similar shapes, represent the world in rather different ways. To the left of the drawing we can see Father Christmas coming down the chimney. On the right, Ben is lying in bed. Ben is composed of a lower case 'b' – ' "b" for Ben', meaning that Ben is in bed. Father Christmas is represented in a different way from the way in which Ben is represented. Appreciating this difference is vital if we are to understand children's development and the crucial difference between symbol and sign use.

Figure 7.2 'Father Christmas goes through a chimney',
by Ben aged three years and three months

We are required to 'read' each image in a different way.

- **Symbols** The image of Father Christmas belongs to a category of symbols which capture something of the shape of the represented object. Adopting Piaget's definitions, I will call these visual or pictorial *symbols*. They include a wide range of pictures of objects and scenes.

- **Signs** A rather different way in which reality can be represented is with the kind of image I will call *signs*. These include letters, words and numbers. These shapes do not physically resemble the things they represent. Their shapes are arbitrary and conventional (Bruce, 1987; Athey, 1990).

Learning is required if we are to understand what they represent.
 I can look at Figure 7.3 and see a horse, but unless I have been taught the meaning of the English word 'horse', no amount of staring at Figure 7.4 will

horse

Figure 7.3 Three ways of representing 'horse'.
First, drawing of a horse, by Ben aged five years

Figure 7.4 Second, the English word 'horse'

enable me to see the animal. The difference between symbol and sign is not
always easy to see, however, neither is the way symbols and signs correspond
to reality. Characters of the Chinese Mandarin language, for example, started off
thousands of years ago as pictures of the objects they represented and to this
day still preserve something of their pictorial origins. The Mandarin character
'mǎ' (Figure 7.5) is somewhere in between the completely arbitrary English

Figure 7.5 Third, the Chinese Mandarin
character for horse (mǎ)

word 'horse' and Ben's drawing of a horse. Young children use drawing to sort
out the differences between how symbols and signs work, and how they
correspond to the world. They investigate how it is that objects, events and
sounds we make can all be represented in two-dimensional shapes on paper.

Ben is now able to draw the closed loop mentioned earlier. This has alerted
him to the existence of looped shapes of many kinds in the visual environment,
including 'b', '6' and 'e'. As with most children, the image of his initial letter is
especially significant to him. He, like other children, has incorporated this letter
into his play world. In this drawing (see Figure 7.2), a human made from a

letter, and a human made of a visual symbol have equal representational status. The closed shape of the 'b' is even drawn resting on another closed shape which represents a pillow! Ben is resting, on a pillow, in bed. Though the two closed shapes which represent head and pillow are very similar, how each corresponds to the real world is different. How far is Ben aware of this difference?

Many researchers in emergent or developmental writing say that young children simply know the difference between pictures and words. This is clearly too crude. There is a time when they play with how different visual structures work. It is as if they are working out how these different images can carry meaning. In order to do this, it is necessary for them to sometimes stretch the boundaries between arbitrary signs and pictorial symbols in order to test the limits of meaning. I believe this is what Ben is doing here and in other drawings of this time. See, for example, Figures 7.6, 7.7 and 7.8, drawn when Ben was aged three years and three months. In Figure 7.6, a rectangular closed shape

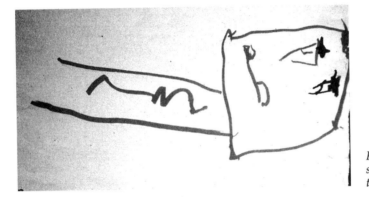

Figure 7.6 'Three astronauts in a spacecraft', by Ben aged three years and three months

represents a spacecraft, inside of which are three astronauts. Two of these are visual symbols for humans. He draws one astronaut in yellow and superimposes on his head a green helmet, and he draws the other in green and superimposes on his head a yellow helmet. This neat alternation of colour-coding helps us to appreciate the strong pictorial basis for these drawn people. Yet existing alongside them with equal status is upper case 'B' for Ben! Ben is the third astronaut, but again, he is represented by an arbitrary, conventional sign, rather than a pictorial, visual symbol.

STARTING TO READ AND WRITE

Children, when they start to read and write, find the letters of their own names very significant, and they tend to interpret these as visual symbols,

incorporating them into their drawings alongside more pictorial images. In Figure 5.8 on p. 67, Father Christmas and his reindeer are flying over a house in which the letters 'B-e-n' are drawn inside a closed shape representing the house, meaning 'Ben is in the house'.

Sometimes in early writing, letter forms are reversed or inverted. There are several reasons why this happens. The orientation of a letter or number shape on the page may not strike the child as particularly significant, after all, it is still possible to recognise drawings of objects even if they are rotated through 180 degrees (Temple, Nathan and Burris, 1982). Another factor is that very young children may not plan their writing, so depending where they start their letter shape determines how it is to continue. The same applies to some early drawings. In fact, Ben at three years and six months would sometimes copy a picture completely effortlessly back-to-front. Left/right, top/bottom drawing reversals are not restricted to children. I am learning Mandarin and I sometimes make left/right reversals with Chinese characters!

Figure 7.7 Letter forms 'describe' what is happening in Ben's drawing, aged three years and three months

In Figure 7.7 letter forms at the bottom of the drawing 'describe' what is going on in Ben's drawing, and to the upper right, another house contains letters of names which stand for the people in the house. There is a fascinating fusion of numbers and visual symbols in Figure 6.19 (p. 83), Ben draws 'six boys with flags'. There are six figures of boys in the drawing, and their flags are made out of '6's! This defeats easy explanation but it does seem that in their play with drawn structures, children make free-flowing associations and multiple meanings. Perhaps this is the start of making puns. This is very important, because it could be the beginning of the child's ability to use representation to reflect on representation itself. This ability to think about thinking develops with age and is referred to by psychologists as *metacognition*.

Figure 7.8 Letter forms are mixed with pictorial images, by Ben aged three years and four months

Figure 7.9 Ben 'copies' his name at three years and three months

In Figure 7.8, letter forms are used almost interchangeably with more pictorial images and they really function as the visual architecture of this two-dimensional landscape. In Figure 7.9, Linda has written 'Ben' for him. Ben, aged three years and two months, has then copied these letters according to his own drawing schemas of action and shape.

Most children are interested in the individual letter forms, but in their play with writing they also capture the linear, rhythmical flow of handwriting. Figures 7.10, 7.11 and 7.12 are drawn by Hannah, one after another, at age four

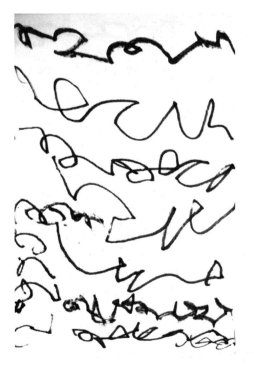

Figure 7.10 Hannah, aged four years and ten months writes a story

years and ten months. In Figure 7.10 Hannah dictates to herself, '. . . Jamie and the magic torch . . . Hannah and the magic torch . . . Ben and the magic torch . . .' carefully 'writing' these sounds as she speaks. Using variations of travelling loop and zig-zag, she is pretending to handwrite. Figure 7.11 shows a drawing she makes to illustrate her writing and which she clearly differentiates from it.

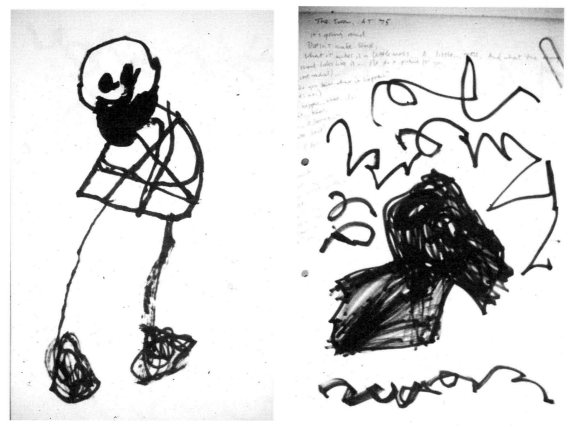

Figure 7.11 Hannah, aged four years and ten months goes on to illustrate her story

Figure 7.12 Writing and drawing sometimes flow into each other. Hannah aged four years and ten months

Figure 7.12 is important because it shows a mid-way stage, in which she partially draws and partially 'writes' the dark shape in the centre. The transcript of the tape recording reveals the way writing and drawing flow into each other. As she moves the pen she says to me, 'It's going round . . . (as she draws rotational marks). It doesn't make sense . . . what . . . it . . . makes . . . is . . . a . . . little . . . mess . . . P . . . P . . . P . . . for . . . Patrick . . . (as she draws the looped form like a 'P' to the left). This looks like a swan . . . because . . . it is a swan . . .' (the writing action blends into a drawing action as she in-fills the shape with black ink). She is aware of the issues of 'making sense'; of 'likeness' and 'non-likeness' in signs and symbols. Like Ben, in understanding the difference between

symbols and signs, on occasion Hannah tests the limits of their meaning by allowing them to flow into each other.

SUMMARY

Nancy Smith (1979) has argued that it is necessary for symbol formation that children, for a while, keep the way signs and symbols relate to the world rather amorphous. Children are aware of the differences between letters, numbers and pictures, but in order to thoroughly understand how they work these shapes need to be incorporated into their play worlds. Here, they are taken apart and put together in different ways, and combined in different ways with a range of visual structures, which all help the child to understand how these shapes encode meaning. Because certain letters (those in their own names, or the names of their friends, or the names 'mummy' and 'daddy') are very significant to them, they become part of their own symbol systems. This means that children's drawing and early writing, though made up from identifiable (and to a limited extent predictable) drawing rules, are unique, personal, visual languages.

There are some important implications for teaching here. We should allow children to free-flow play with written and drawn characters (Ferreiro and Teberowsky, 1982). In the teaching of literacy there has been a shift of emphasis from the idea that reading is best taught as a series of visual and motor skills (recognising shapes, training hand movements and scanning lines of print and so on) to the idea that it is to do with understanding and making meaning (Whitehead, 1990). Thomas and Silk (1990) have made the important suggestion that researchers of emergent writing should look more closely at how children draw. We all have to expand our notion of literacy and what it means to 'read' and 'write'. This expanded definition has to include all kinds of visual images – those made from physical paint, pens and pencils of all kinds and those produced electronically, for example, on a computer. We should also be aware that children cannot just copy any letters or numbers. In writing, as in drawing, they start to notice and produce those shapes which they themselves have already started to produce on the drawing surface. This means that children take an active part in the construction of the visual environment of pictures, written language and numbers.

8 SPACE, DEPTH AND INFINITY

So far we have seen that children explore the relationships between lines, shapes and colours. In addition, they give powerful emotions to painting and drawing actions. They might notice that their moods effect the quality of the painting in different ways. They also start to realise that lines and shapes, and the actions out of which these are made, can convey representational values. They associate drawing actions with other actions of the body. For example, painting might be synchronised with singing and dancing.

In this way, they begin to realise that a painting action can represent or 'stand for' another action. This is the start of an important realisation that relationships between lines, shapes and colours emerging on the drawing or painting surface are like relationships in the world. They can represent objects and events in the real world. They also start to learn that representations carry meaning in different ways, and in their early writing they are starting to use representations of representations.

CHILDREN BEGIN TO SHOW DEPTH IN THEIR DRAWINGS

By thinking about the different meanings suggested when lines and shapes are joined together in different ways, many children start to glimpse another representational possibility. Most children, as they mature, seem to want to show depth in the relationships in their drawings. We do not know if this is a natural, universal tendency or whether it occurs because of cultural influence. Some forms of art are not concerned with showing the third dimension at all. Islamic art does not represent any living thing, nor the environment where such things live, but uses mathematical patterns – the deep structures of representation. Where art has been concerned with representing the third dimension, the way in which this is shown varies enormously from culture to culture, and from time to time.

While some societies have an expectation that children should show the third dimension in their drawings, and some even try to coerce them into doing so, this is not a satisfactory explanation of an often-seen process of development. It is very important to understand that the steps children make towards this cannot be accounted for by the kinds of instruction or even coercion that they might receive. As children try to represent, they often come up with solutions

which they would be unlikely to have encountered in their own societies. They produce pictures which they would be unlikely to have seen in books or on walls. (Significantly, some of these representational solutions do exist in other places and at other times, and I will mention these later.) There is a strong tendency for children to try to add the third dimension as they draw and paint. This is very clear in Ben's development. The drawings he makes partly reflect the way in which he builds, as he grows older, an internal description of reality in which all its different aspects – height, width, depth, mass, weight, movement, plus the imagined psychological states of imaginary people in this world – are all coordinated. This is eventually so fully worked out that he is able to imagine himself moving through it to any position and, from there, imagine what the view would be like.

In this chapter we will consider how Ben coordinates these different aspects of his represented world. In some respects, Ben's drawing developed more fully than that of many other children. Drawing and painting formed a central part of his life. However, I am using this sequence because it clearly illustrates a path of development which does have something in common with other children and because careful analysis of the sequence of steps through which he moves, sheds light on how one might help other children's visual representation. For example, Ben has encoded topological relationships, like inside and outside; boundary; and hollowness. Gradually, he starts to define objects on the paper, not as simple closures, but with additional features with which to identify them. (A closed shape can be made long, for example, to show something long like a crocodile; or corners might be added to a closure to depict corners of a car or house.) Ben, like most other children, also combines shapes together to show differentiation within forms, like the way legs are different from, but are attached to, bodies. He also shows that some objects are above or below other objects. In this way, he maps onto the drawing surface a vertical axis. These steps are typical of most children.

Looking from a particular point of view, or a variety of points of view

What is less typical of other children – though not absent altogether – is Ben's realisation that shapes can suggest certain lines of sight or points of view. For example, he has realised that a closed shape could represent a ninety degree line of sight to an object (or 'face-on' view), and that a single line could represent a line of sight of zero degrees to a flat plane (or completely foreshortened view). This is a very important discovery, and we shall see how he develops it.

Eventually this discovery that drawing can suggest flat planes rotated through ninety degrees, is coordinated with the understanding of how movement of objects can be represented on the paper. At first, Ben thought about successive points in space and time through which an object moves. This started with continuous lines or sequences of dots across the page, from one side to another. In Ben's case, these were gradually resolved into serialised images or 'picture stories' (also produced by other children) of kings falling off castles, boats taking off out of water. Note that these picture stories are unlike the comic strips in which sequences of movement are broken up into individual 'frames' (see Figure 8.1 where Ben draws a pirate moving through a secret tunnel and then through the air, in a sequence of positions through time and space). They have more in common with some early Renaissance paintings in

Figure 8.1 A serialised image showing movement through time and space, by Ben aged four

which an image is repeated within the same picture to show the same figure at different moments in space and time. For example, a fifteenth-century painting by Giovani di Paolo shows John The Baptist walking off into the landscape and he is shown in two positions, first of all at the beginning of his journey, and also later on, when he is further into the mountains.

We can interpret Ben's serial images in various ways. Either there is no fixed point of view; there is a multiple point of view; or the viewpoint is not specified at all. In any event, Ben gradually considers how an object recedes away from him or comes towards him. In doing so, two important new things happen. Firstly, by thinking of a new direction of movement in space, he finds a new way of showing depth on the drawing surface; and secondly, by thinking about this direction of travel, away from his own body, or towards it, the relationship of an imaginary observer to the scene becomes important. It is as if someone is looking into the picture, through a window opening onto the scene. The edges

of the paper are like the window frame. In other words, he is creating a single viewpoint. Through this window we can see objects getting smaller or bigger, as they come towards us or move away from us. Gradually, Ben is acquiring the freedom to move around his internal model of the world and study the scene from different positions. A similar change is reflected in the paintings of the Western Renaissance. Gradually, the painter became an individual; an independent agent free to move through three dimensions of space and the dimension of time.

Drawing a stage coach that moves away from us

We can see the start of this in a drawing Ben makes when he is only three and a half (see Figure 8.2). A stage coach moves along, not only from left to right but also away from us into the distance. He achieves this effect by making the

Figure 8.2 A stage coach recedes into the distance, by Ben aged three years and six months

repeated drawing of the stage coach get smaller to represent the stage coach moving away from someone watching it. He represents on paper how objects *appear* to get smaller as they go away from us by a controlled change in the *actual* size of the drawn image. Children understand that the size of most objects remains constant – they do not normally shrink. This might seem very obvious, yet in order to show in drawing that they move away, it is necessary to put severe constraints on this knowledge, and to put it 'on hold'. This means that Ben is forming a different attitude to the drawing surface. He is imagining that the paper is like a window opening onto a physical world. I write 'like' because in some extremely important respects, it is nothing like this at all. It means forming and coordinating a quite new set of drawing rules. Ben uses mostly the same kinds of shapes, lines and line junctions he has used before, but he is gradually changing their denotational values.

One important example is the new representational values associated with oblique lines. We can see the glimmerings of this in Figure 8.2. If we placed a ruler on the drawing so that it touched the top of each stage coach we can see an

implied oblique line. In later drawings this oblique line will become more explicit and the new way in which he uses the oblique line signals a revolution in drawing development.

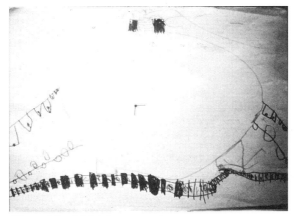

Figure 8.3 Multiple aspects of a steam engine by Ben, aged four years and three months

In Figure 8.3, produced at the age of four years and three months, he shows us four views of a steam engine and its carriages. There is the front view of the engine; a plan view of the railway tracks; and a view of each side of the carriage. Such drawings have often been termed 'fold-out' drawings, but as Arnheim (1974) has pointed out, this is a misnomer, because nothing, for the child, was ever folded in the first place! This term, like others given to various kinds of children's drawing, reflect adults' – not children's – lack of understanding.

Drawing which combines two different sorts of knowledge about trains

On the one hand there is 'object-centred' knowledge which is about the main characteristics of objects irrespective of any particular viewpoint. That the carriage has two sides is an important part of this knowledge. However, Ben has been influenced by 'viewer-centred' knowledge which is about how things appear from a particular viewpoint. So, even though he has shown two sides of the carriage, which cannot be seen simultaneously in real life, each carriage side taken individually is like a view of the carriage. This is because of the new use to which he puts oblique, parallel lines. These lines represent the roof and floor of each carriage. The significance of this is that the slanting lines represent edges which in reality, do not slant. Within the context of this drawing, these sloping

lines do not represent physical slopes; they show horizontal edges which recede away from the viewer of the picture.

THE IMPORTANCE OF UNDERSTANDING CHILDREN'S THINKING

It is important to remind ourselves that Ben's development does not happen in a vacuum. There is a social context which includes interested and informed adults talking to Ben about how the drawings work; a ride on a real steam train; and also other people's pictures of steam trains. Ben had been very interested in steam trains from the age of two years and ten months. He used to cover a toy engine in rolls of Plasticine to represent the smoke coiling and wreathing around it. We travelled on the Isle of Man's steam railway. He played at being a steam train, even insisting on 'shunting' backwards along pavements making 'choo-choo' sounds. Ben started producing many drawings and avidly collecting photographs and other pictures of steam engines. He also liked children's books about steam engines, including 'Thomas the Tank Engine'. Although his serialised images of steam trains were not like the comic books he looked at, the discussions with Linda and me about how these comic books worked did help develop his ideas about how to show movement on paper and about the structure of events. This is also true of the way he used other images.

When Ben looked at photographs, they were, of course, in perspective, as were many of the pictures he collected. Yet Figure 8.3 (p. 101) is not in perspective and is unlike any of the pictures in his collection. Again, we have a glimpse of how his schemas allow him to organise his experience. Some aspects of the collected pictures have been accepted (assimilated). Others have not. For instance, in some of his collected pictures, parallel oblique lines represent receding horizontal edges of carriages. Ben has been able to assimilate these to his existing schemas. He has been able to accept the new idea that sloping lines do not necessarily mean slopes. He has learnt this by discussion and by analysing the two-dimensional structure of his many examples (which indicates the stupidity of some 'art-education' advice which forbids children to use ready-made, or 'secondhand' images – to use the misnomer coined by these 'advisors').

He has not been able to use other aspects of his collected pictures. When he draws perspective views of trains, oblique lines do not remain parallel but converge at the horizon at a vanishing point. Ben is not yet ready to use this convergence of top and floor of the carriage. Perhaps it conflicts with his object-centered knowledge that the floor and roof of the carriage must not touch.

Errors are sensible decisions

The so-called errors in children's drawing are not errors at all, but sensible decisions about which information should be encoded in a drawing. Children's priorities about which information to keep and which to sacrifice, changes with age and also depends on the context. At this time, Ben may want to preserve the parallel relationship between roof and ceiling. Other children resist showing depth when drawing objects like tables because this would sacrifice parallel edges and right-angled corners.

It is worth reminding ourselves that just because children may not use a certain drawing system, this does not mean that they cannot produce the types of lines required. Ben has been able to produce converging and parallel lines since the age of about two-and-a-half years. His use of parallel lines in Figure 8.3 (p. 101) is not explained in terms of motor-skills development but in terms of a conceptual, imaginative and intellectual leap. The revolution going on in his drawing is to do with the *meanings* of the lines – not the lines themselves.

HELPING CHILDREN GET ON WITH THEIR DRAWINGS

The teaching implications here are that we need people who understand these drawing systems and who can talk to children intelligently about how they work. We need people who can identify the beginnings of these systems in children's work; possibly even pointing out to them the connections between these and the same systems used by adult artists. This may seem daunting, but in actual fact children do not always need much advice, although when it is given, it does have to be of the helpful kind. They do much of the work themselves, as they try to resolve ambiguities in their drawings which they themselves find unsatisfactory or disturbing. As children draw, they receive visual feed-back, and they then try to change the look of the drawing in response to this feed-back, as can be seen in the following example.

In an earlier engine drawing (made at three years and three months) the wheels are placed upon the uppermost line of a plan view of a railway track (see Figure 8.4, overleaf). A year later, as shown in Figure 8.3 (p. 101) Ben is still making decisions about which line the wheels should rest on. He now has some additional sortings out to do with the carriage sides. We will gradually see him resolve and coordinate these problems. Arnheim (1974), and Willats (in personal conversation), have argued that progress in drawing is unlikely to arise from

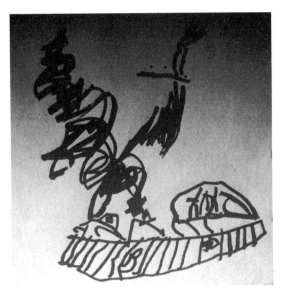

Figure 8.5 A line of steam engines recede to the horizon, by Ben aged four years and three months

Figure 8.4 A steam engine, by Ben aged three years and three months

the child being exhorted to somehow 'look more closely' at nature, but out of the child's looking at what emerges on the drawing surface itself. We can see this happening in Ben's next drawings. It is significant that Ben produced only one example of the so-called 'fold-out' drawing. This might be because he perceives in the finished drawing (and perhaps in the drawing procedure) certain ambiguities which he tries to resolve in subsequent drawings.

Over the following weeks we see him trying to sort out the potential conflict between information which tells us about the object in itself, irrespective of any fixed viewpoint; and information which does specify a particular view-point to the scene. In Figure 8.5 we can see a line of steam engines receding back to the horizon. He has left out the sides of the carriage in this drawing, perhaps in the spirit of tackling one problem at a time. This drawing is an important landmark in his control of grading size difference to show moving away in space. Compare it with the stage-coach drawing he did nine months before (see Figure 8.2). In this new drawing, we can see again that implied convergence between an imaginary line which connects the wheels and another imaginary line which connects chimneys.

Produced a week later, Figure 8.6 shows just one side of the carriage. An oblique line now means a horizontal edge which recedes from us. One month before, a sloping line usually meant a physical slope (see Figure 8.7).

It is important to say that, in common with most children, and contrary to the assumptions of most drawing research, depth depiction is not the sole or most

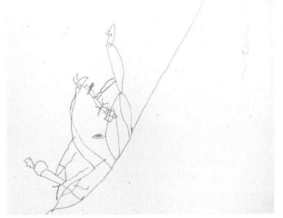

Figure 8.6 *A steam engine. The sloping line of the carriage roofs stands for a horizontal edge receding from us, by Ben aged four years and three months*

Figure 8.8 *A strange figure drawn by Ben aged four years and three months. Note the encircling belt*

Figure 8.7 *The sloping line in this earlier drawing, by Ben aged four years and two months, stands for a physical slope. A cowboy and knight in armour climbing a hill*

important concern in Ben's drawings during this period. He also produced quite fanciful drawings. In these, the devices he uses elsewhere to show depth are used differently, they are decorative embellishments rather than lines and shapes which show volume (see Figure 8.8).

Showing the third dimension of depth is only one of an entire set of possible concerns children might have in drawing. It is not, as many people believe, the major end-point of drawing development. For example, in Figure 8.9 (overleaf) Ben seems to be thinking of the figures in terms of arrangements of flat shapes balanced in ways only possible within this two-dimensional world. Even the three dimensions suggested by the folded tail fin of the fish is notional rather than realistic. Another example is shown in Figure 8.10 (overleaf). This strange

Figure 8.9 Figures with fish, by Ben aged four years and three months

Figure 8.10 A strange figure, by Ben aged four years and three months

seafaring man has an interesting fez and spectacles. He also has a picture of a man on his shirt. Is Ben making a play of representation within representation? Also, notice the distant ship which, although drawn at decreased size compared with the foreground figure, nevertheless functions in a decorative or emblematic way, rather than as a device to show distance.

Ben uses his new knowledge about how to show depth relations, but this knowledge is not stuck in any narrow system for producing so-called 'realistic pictures'. Rather, he combines a range of drawing devices to produce hypothetical universes. He also blends different genre (Wolf and Perry, 1988). Ben already knows that there are different styles of pictures, and what would be appropriate for one might not be for another. These drawings cannot be accounted for with that tired, old idea that children draw like this because they are unable to draw depth relationships between objects in their pictures. Ben can do this if he chooses to. Children generally choose between a range of expressive and representational options. This has not usually been noticed, because the ways children do this do not fit into the definitions of most drawing research.

Figure 8.11 An extreme, low-angle view of a giant stepping over people, by Ben aged four years and three months

Figure 8.11 shows a worm's eye view of a giant stepping over people. We have a very low-angle view of the giant, so close to his feet that they appear enormous, so far from his head that it appears tiny. Some people might object that the feet are big merely because Ben happened to be interested in feet; that these were drawn first, not allowing him much room for the rest of the figure. It is true that this can happen in many children's drawing, but it is not true of this drawing. Listening to Ben talking his way through this and other drawings confirms that he was trying to show depth. Another idea, that the larger the image drawn (in the case of the giant's feet) the greater the emotional significance, may have been overemphasised. This is another example of an idea which has become part of the folklore of children's art, probably obscuring other drawing devices, especially the showing of depth relations. Nor is it true that the giant merely has disproportionately big feet. These are 'normal' giant's feet! They are drawn larger because they are close to the viewer. There are even converging lines, perhaps the beginnings of true perspective, in the form of the giant's legs. Like other children, as Ben becomes interested in viewpoint, he imagines himself moving, and imagines what the scene might look like from a variety of positions.

In another drawing, made a few days later, he shows the giant being crowned (see Figure 8.12, overleaf). We can see, to the right, a large, long, complex closed shape which represents the giant's crown. It is being carried by little helpers. When people carry large, cumbersome, heavy objects, there are problems. One of the carriers topples back, arms outstretched, into a hole, but is fortunately caught by a colleague. The story unfolds on the paper, sometimes his running commentary leading the drawing, sometimes the other way around.

The crown is to be carried along to the left side of the picture where it will be

Figure 8.12 'A giant being crowned', by Ben aged four years and three months

lifted up onto a series of platforms until it reaches the giant's head, a tiny closed shape, way, way up in the sky. Think about the relationship between crown and head. Ben is playing with the idea that, as the crown is moved towards the giant's head it will diminish in *apparent* size until it fits the head. Ben is playing with viewpoint and relative distances between the observer and different parts of the scene.

By the age of four years and four months he is making the nearer boots of soldiers pacing towards us larger than their further boots. Nine months later, a native North American indian is viewed from an extreme low angle, with his leading moccasin looming hugely towards our eyes; so close we can see the decorations on its surface (see Figure 8.13). In another drawing made at four years and five months (see Figure 8.14), a horse, cowboys and red indians

Figure 8.13 Extreme low-angle view of native North American indian, by Ben aged five years and one month

Figure 8.14 'Cowboy country', by Ben aged four years and five months

fighting, cowboys ascending a tricky summit, and a man hiding behind a wagon wheel are all drawn according to his criteria for realism. A study of the imagery on a 'Wagon Wheel' biscuit wrapper, for example, formed part of his careful research. But look at the Sun. It is encircled with gun holsters and has a cowboy hat, complete with sherrif's star. When I questioned him about this he looked at me as if I was simple and explained, 'It's because it is in Cowboy Country!' This poses a question about what is 'realistic' for young children as they draw and the way we evaluate their work.

In his series of drawings about 'pirates fighting', we see many of his themes and understandings becoming coordinated. Look at Figure 8.15. Without a real

Figure 8.15 'Pirates fighting', by Ben aged four years and six months

knowledge of his intentions, and with naive ideas of 'visual realism', many would judge these figures to be deformed and anatomically out of proportion; yet these shapes are the result of Ben's intense effort to imbue them with movement. He makes battle sounds as he draws. This is a development of those earlier associations between song and drawing action. In between bouts of drawing, Ben throws down his pen, stands up and, with his whole body, acts out the drama of a bout with an imaginary opponent. Then he sits down and continues drawing, perhaps armed with kinaesthetic information (about movement) and what is called proprioceptive information (about the positions of his joints and limbs; about balance, posture and stress); perhaps even with an internal representation of the other person. Hence, the shapes on the drawing surface are not distortions of forms but attempts to give the drawing movement.

This happens when he comes to draw important detail. The man on the right is being struck by his opponent's sword. Ben is showing the knotted muscles around the eyes as the pirate screws up his eyes in agony. This is a very unusual

configuration for the eye region. Again, Ben acts this out, screwing up his eyes in simulated agony, opening his mouth wide, yelling. In the drawing, we can see this open mouth, the tongue showing. The man's eyes and mouth are drawn very differently from those of his opponent, whose eye is a dot, and whose mouth smiles. He smiles because he is winning. In this way, Ben marks the difference between victor and vanquished. This is an example of how children's drawings are not fixed, but vary according to what they are trying to do and the context of their drawings. It is vital that we appreciate this when evaluating children's drawing. Children do not always draw a person the same way.

The face of the victor is different from the face of the vanquished. Ben is differentiating between the two psychological states of the pirates. The depiction of the imagined thoughts and feelings of imagined people is just as important in drawing as showing depth and three-dimensional volumes. The thoughts and feelings, intentions and motivations of other people are worked out in pretend play with imaginary people in imaginary worlds.

Like many of Ben's drawings at this time, this work is extraordinarily complex, using a wide range of understandings and influences. In addition to carrying powerful themes and content, this drawing is partially composed from a 'join-the-dots' procedure! His interest in this, like other children, comes from his topological understanding of how things connect and how a line is made up of a series of points along a route.

Occlusion and hidden line elimination

The pirates are superimposed over each other, but Ben soon finds another, powerful way in which lines and shapes can create space. He realises that it is not necessary to draw certain parts of a form if, from a particular viewpoint,

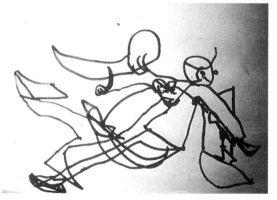

Figure 8.16 'Pirates fighting', by Ben aged four years and six months

these would be concealed from the viewer. In the drawings of pirates fighting, we see Ben gradually leave out those lines representing forms which would be concealed by other forms nearer the viewer. In Figure 8.16, his second drawing, most of the shapes in the drawings are superimposed over each other, but at the bottom right we can see that Ben has left out those lines representing the part of the ship's mast concealed by the leg of the pirate. The concealing of one shape behind another in drawing is a special kind of overlap called *occlusion*. Leaving out the lines of the hidden or 'occluded' part is called *hidden line elimination*. It is unusual, however, for children of Ben's age to use these devices, usually, they feel it important to show the whole object as an entire, coherent form with uninterrupted boundaries.

In Figure 8.17, his third drawing of pirates fighting, produced a few days later, his understanding has reached a new level. There is no more

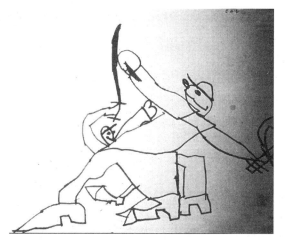

Figure 8.17 'Pirates fighting', by Ben aged four years and six months

superimposition. Ben uses hidden line elimination and occlusion throughout. When children discover a new language rule (for example the use of the full-stop) they often use it extensively, with great enthusiasm. In a similar way, Ben makes extensive use of these new drawing rules. The drawing is a dramatic arrangement of shapes, which overlap or occlude each other. There is an entire, undrawn body of one pirate hidden behind the other. His pointed, platform shoe is partially hidden by the other, its toe poking out of the other side. Ben is using what he knows about how things move; how a moving shoe disappears behind another and, without breaking a continuous, smooth path of movement, reappears on the other side.

Foreshortened planes

Earlier, we saw how Ben's drawings of 'beans on toast' and objects 'on top of tables', showed foreshortened views of flat planes. In Figure 8.17 (p. 111) we can see the hilt of the sword of the nearer pirate 'face-on'; that is, we have a line of sight of ninety degrees to its surface. The other pirate's sword hilt is shown completely foreshortened, or 'edge-on'. We can see how Ben's representation of depth has developed from the previous year. Other ideas about conflict, pain and death are involved in many drawings at this time.

For some time now Ben has used the drawing surface as a 'window' in some respects. Now he has taken that viewer-centred approach a little bit further, to use this 'window' to show just part of the scene – like the viewfinder of a camera. In Figure 8.18 a soldier's face is so close to us that we can see the embossed pattern on his helmet and the scars on his face. The picture only

Figure 8.18 A scene of a battle, by Ben aged four years and six months

shows his head, the rest of his body is 'cut off' by the bottom edge of the paper. Unseen protagonists are outside the frame, thrusting swords into the picture. In fact we can only see a part of the entire battle suggested by the picture.

This is unlike most other children's drawings made at the same age. Usually, children use the paper as a physical target, putting everything with its entire, unbroken form preserved, into the picture. In Ben's drawing, the edge of the paper itself occludes or hides massive sections of a scene which exists only in his imagination. Looking at the picture, we also need to use our imagination to fill in the gaps Ben has left, although as adults we are so used to this drawing convention that we are usually unaware of this.

Of course, this effect only works if all the elements within the picture obey the same rules. There is one part of Ben's picture which slightly contradicts this projective dimension. That is, the meaning of the line making the top edge of the embossed helmet. A distant figure runs up it as if it were a hill! However, even this ambiguity may be intentional. Even at four years and six months Ben may be making a game out of the rules of representation. A feature of children's

play of importance to teachers and caregivers is that one can only play with rules when one has understood them (Opie and Opie, 1959). Ben does understand the drawing rules he is using. Such play with drawing rules is the forerunner of the more conscious use we find in later childhood and adolescence of using representation to reflect upon representation.

Foreshortened and face-on views of an object represent two key moments in time

These are two opposite views. They can only be understood as representing the same object because of the child's understanding of sequences of events. These key moments in a sequence of action, when represented in images, tell us not only about the object themselves but also about the object's past and future positions. Hence, drawings which show viewpoint often tell us about past and future states of affairs. Pictures which show how scenes look from a particular position in space also show a moment in the flow of time. This is also true of the perspective pictures of the early Renaissance (Costall, 1992).

At just over five years of age Ben produces a range of drawings in which spatial and temporal relations are further elaborated. In Figure 8.19 a knight in

Figure 8.19 A knight in armour and a knight on horseback, by Ben aged five years and one month

armour waves a sword at a knight on horseback. Look how he draws spherical objects, such as the knight's helmet, with its visor which describes the curving surface. A belt encircles his waist in a now sophisticated use of occlusion and hidden line elimination. This is also a development of the understanding 'going round'. Look also at the difference between the construction of this figure and the one on horseback. Although Ben is an unusual draughtsperson, most

children vary their drawing construction according to context. The horse is interesting in this respect, being almost like a table in back-to-front perspective, with attached horse's head and mane. When children do not have much experience of a subject, they adapt their existing drawing schemas to the situation as best they can.

Further evidence that time and space relations are involved in visual representation is shown in Figure 8.20 made by Ben at the age of five years and

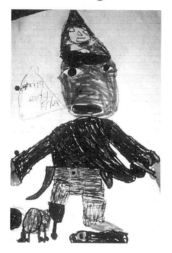

Figure 8.20 'Aha there Pirates!', by Ben aged five years and four months

four months. The man is saying, 'Aha there Pirates!' Because he is now at infant school, I tentatively suggest to him that the words and letters are back to front. He looks at me as if I am stupid and says, 'Don't be silly, the words come out of his mouth that way!' Even at this level, drawing and writing are still rooted in children's understanding of patterns and directions of movement.

From the age of six and a half, Ben produces a series of drawings based on his experience of 'Star Wars' movies (see Figures 8.21 to 8.26). It is interesting to

Figure 8.21 Spacecraft, by Ben aged six years and six months

Figure 8.22 Spacecraft, by Ben aged six years and six months

Figure 8.23 Spacecraft, by Ben aged six years and six months

Figure 8.24 Spacecraft, by Ben aged six years and six months

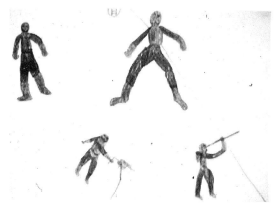

Figure 8.25 Spacecraft, by Ben aged six years and six months

Figure 8.26 Spacecraft, by Ben aged six years and six months

compare these drawings with the original images from the films. As we have seen right from the outset, Ben's drawing is influenced by other people's pictures only to the extent that he is already drawing similar structures. His drawing of spacecraft are rather different from the originals because he filters these influences through his own internal schemas. We have seen this process again and again from infancy. It tells us something about appropriate teaching, what to suggest to children and what not to impose. Our provision of examples should be guided by careful study of how children organise their drawings. This does not mean that children can only draw what they already draw, or should only be given subjects which they can already draw. New suggested subjects need to be based on the children's drawing schemas, but they should also require them to adapt and revise existing drawing schemas, or to combine them in new ways. Actually, this tends to happen naturally. There is rarely an

exact match between subject and drawing schema. This is the approach advocated by Vygotsky (1986) and others, in which the teacher is anticipating what the children are moving towards. This process is assisted by the children's spontaneous search of the visual environment for subjects which, although they fit to some extent existing drawing strategies, also demand revision and adaption from the children.

Ben intersperses drawings of spacecraft with other subjects which nevertheless requires him to elaborate the ways in which he articulates forms in space. The drawing of skateboarders (see Figure 8.27) is one example. It is an unusual drawing for a child aged six years and ten months.

Figure 8.27 Skateboarders, by Ben at six years and ten months

How has he achieved this? Does he have a complete picture in his mind which he somehow copies? This is almost certainly not the case. More likely, is that it is an interaction between his internal pictures and the shapes which appear in the drawing. Gradually, he has been able to coordinate and internalise a range of different views and can manipulate these in his mind. When he draws, he modifies these internal pictures according to the spatial relationships suggested by the shapes appearing on the paper. In a two-way process, his internal pictures guide his drawing and, reciprocally, what he draws, as it appears on the paper, helps his internal picture to develop. Drawing helps him rotate objects in his imagination.

So how has he built up these internal pictures? He has created miniature worlds in play in which handheld toy air and spacecraft, vehicles and people, are carefully moved through a range of orientations in three dimensions. In this play he adjusts his line of sight to the toys, seeing how they look from different positions. He discovers the technique of closing one eye to view the scene, cutting out the variation between the images of two eyes. This is a device which artists sometimes use in order to see three-dimensional scenes as single images from single viewpoints. Try it yourself. Perspective drawing is based on this one-eyed vision of the world.

Whilst undoubtedly he has inherited genetic predispositions and abilities from Linda and myself, I do not believe that his achievements can be completely explained by this. In all of this he has been assisted by careful discussion with us, in which his play and representation has been recognised and supported or extended by suggestions in line with his intentions. The skills he has formed in the handling and viewing of objects are at least partially the result of a special kind of childcare. Most children can be helped to achieve these skills.

Visual jokes: the relationship between humour and intellect

At just over seven years, Ben draws a picture of a motorbike made completely out of bananas (see Figure 8.28). When, and only when, one has complete mastery of a representational language can one make visual jokes and amuse friends. Humorous acts are intellectual achievements based upon competence with representation (see also Athey, 1977 and Reddy, 1991).

Figure 8.28 'A motorbike made of bananas', by Ben aged seven

John Willats's work (1984) suggests that the way children represent depth in their drawings is a self-driven, internal process. My own work supports this idea. However, Willats has suggested that when it comes to linear perspective, this will not normally be spontaneously discovered, but needs teaching. If this is so, when and how this teaching should occur is a vital question. We have seen that children cannot be merely 'trained' in perspective. Indeed, teaching any of the projective systems should be guided by careful observation and identification of the type of projective system children are using.

Other subjects of Ben's drawing include the Normandy rescues in World War

Two. Some of this drawing, produced at just over nine years was derived from the history books he was reading. However, the image on the back of one drawing (see Figure 8.29) shows a low-angle view of a dead soldier, lying at the edge of the sea, and as far as I know, was not derived from a book or film, but was the result of his pondering the consequences of war.

Figure 8.29 'Dead soldier', by Ben aged nine

Destruction, injury and death also have a funny side. If that sounds shocking, think about the jokes adults and children make about these subjects. We have to find the funny side of mortality. Figure 8.30 was produced at nine years and three months and shows a weary looking robot who, after an exhausting climb up a vertical ladder, has reached the top – only to be blown up a moment later. We can predict this by looking at what befalls his colleague who precedes him. In this drawing he conveys past and future states.

Figure 8.30 Robots get blown-up, by Ben aged nine years and three months

Figure 8.31 Robot exploding – close-up, by Ben aged nine years and three months

The drawing shown in Figure 8.31, made a little later, shows a close-up of an explosion. This change of view (or 'shot') is a cinematic effect. From the outset we have seen children coming to terms with the major scientific fact that, in this

universe, things tend to fall apart. Drawings like this one are a continuation of these concerns in which humour takes the sting from disorder and death.

IMPLICATIONS OF BEN'S DEVELOPMENT

The drawings depicted so far have focused on the first eight years of Ben's drawing ability. However, it is important to understand something of Ben's later development, in later childhood and adolescence, if the implications of the beginnings of drawings and paintings are to be fully appreciated. We have seen that drawing is a continuum of meaningful symbolisation which starts with the first drawing movements and marks. The ideas of Vygotsky, Piaget and Wolf suggest that this process is best understood as a conversation between the thinking child, his or her representational intention and the unfolding drawing (known as a dialectical relationship). As Wolf (1989) suggests, the emphasis in this relationship changes as the child grows up. Whereas the younger child sorted out what the lines and marks stood for in the real world, the older child is more aware of further layers of meaning. The older child realises that a description of the surface content or structure of a picture may not in itself reveal the full meaning of an art work. The older child is aware that there are hidden meanings. He or she is more in control of metaphor, that is, the use of lines and shapes to stand not only for edges, boundaries and volumes in the world, but as ideas, feelings or themes for which there may be no literal description.

Figure 8.32 'Rise and Fall', by Ben aged fifteen

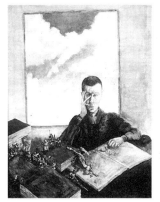

Figure 8.33 'Absorption', by Ben aged fifteen

Some of Ben's teenage drawings exemplify this. Figures 8.32 and 8.33 were produced at the age of fifteen. They were made after he was recovering from a brain tumour which nearly killed him. Figure 8.32 is called 'Rise and Fall'. As in

many of his drawings of this time, this work shows an individual in serious trouble. The man is falling, seriously injured. The outcome remains uncertain. He may rise again, we are not sure. Or he may rise again only to fall again – perhaps locked in a cycle of death and resurrection. Figure 8.33, was produced for his 'O' level GCE exam and is entitled 'Absorption'. As in 'Rise and Fall', the double meaning of the title is more typical of the older child. Ben is depicted as an artist absorbed in thought. He is playing a game of life and death. Influenced by the work of the artist Escher, three-dimensional soldiers and a dragon arise out of the two-dimensional surface of his drawing (see Figure 8.34). They will

Figure 8.34 'Absorption' (detail), by Ben aged fifteen

experience a short period as three-dimensional beings before merging into the two-dimensional world again. Using ideas from 'Fantasy Role Playing Games', popular with teenagers at this time, the moves of the game of life and death are partly determined by a roll of a dice. We are not sure of the status of the game player. Is his life dependent on the roll of the dice? Or is he God, the Games Master, who can see eventualities hidden from the rest of us? Or does God too, along with the rest of us, have to take his chances?

In both these works we can see a continuation of those themes which emerged in babyhood and infancy, when Ben thought about the beginning and ends of journeys. Now he is thinking about the beginning of life and its end; about where we come from and where we go.

HOW DOES THE STUDY OF BEN COMPARE WITH STUDIES OF AVERAGE DRAWING DEVELOPMENT?

Statistical pictures of the average child's drawing have limited value unless we add to these detailed studies of individuals like Ben who use a representational medium intensely and develop at least some of its potentialities to the full.

Autistic child artists

Because Ben's abilities are not restricted to skilled use of visual media, this study is more useful to teachers and caregivers than those of rare autistic child artists. No one really knows why children like Nadia and Stephen Wiltshire draw in the way they do. One idea is that because autistic children do not relate to the world and to people in the normal way, and are unable to play representationally, they may by-pass representational problems which confront normal children. Because the world does not hold for them the profusion of knowledge it does for most children, autistic children might more easily reduce it to a flat visual field than ordinary children are able. However, very few autistic children are artistically gifted and another theory is that they are better able to translate visual images in their brains into the motor-skills necessary to draw it on paper.

Most authors on autistic drawing claim that it is totally different from typical development. This is misleading because there are commonalities. When I observed Stephen Wiltshire drawing, he made excited sounds and movements in synchrony with his drawing actions, like the basis of representation we have studied in this book. It was hard to conclude that these actions were mimicry. Also, most accounts of autistic child artists argue that, because they cannot represent like other children, they miss out 'stages' of development through which most children pass. It is far from clear that this is true. Given researchers' predilection for visual realism, the earliest drawings of these children were not collected. There is evidence that Nadia, for example, passed through a brief scribbling period (Golomb, 1992).

Other gifted child artists

Other gifted child artists, not impaired by autism, also seem to pass through a developmental sequence similar to most children. The Chinese girl Wang Yani, for example, at age two and a half produced very beautiful rotational drawings and U-shapes on baselines which, like many of the children in my own observations, she called 'mountain' and 'bridge'. Her first animal paintings at this time were composed of closed shapes with marks inside, and right-angular attachments. She received encouragement for these paintings from her father (Zhensun and Low, 1991). Information about the beginnings of gifted children's drawing is usually skimmed over in favour of documenting the impressive artworks of their later years. This is a pity because such information would be very useful in what it might tell us about how these children extend universal

strategies, and how this process might be supported by adults.

Studies of these children do not, as is sometimes claimed, throw all developmental theory of drawing into disarray. Explanations of autistic artists are muddled by a naivity about drawing. Lorna Selfe (1977), for example, misleadingly terms Nadia's drawing 'photographically realistic' and she equates skilled drawing with deficits in other areas of cognition, thus perpetuating the myth that artists are unintelligent or strange. We need more careful studies of intellectually able children who are skilled in drawing to help dispel some of these myths of drawing development.

Summary

In this chapter we have looked at how children show depth in their drawings. Whether this is a universal, natural activity, or the product of cultural influence is controversial. However, it is difficult to account for this development solely in terms of a simple imitation of cultural examples. This is because children often use pictorial devices they would not encounter in other pictures around them, and when they do use strategies used in pictures they might see, they combine these in ways which reflect their internal processes of organisation, rather than the source pictures themselves. As they grow older, children may become sensitive to further levels of meaning. Whereas the younger child worked out what Willats (1985) terms the 'denotational values' of lines – what the lines stand for in the real world – the older child and adolescent may use images as metaphors for ideas, feelings and concepts (Wolf, 1989). This does not mean that this aspect is completely absent from the young child's representation. Indeed, early years teaching should provide for this possibility because this will influence the extent to which teenagers can consciously manipulate imagery to express ideas.

We also considered the relationship of Ben's drawing with studies of other unusual draughtspersons and painters. I suggested that, as with Ben's drawing, the development of the painting and drawing of these atypical children may share important features with that of more typical children. That this has not been generally acknowledged is due to the fact that those who write about these gifted children have failed to notice and understand the beginnings of the representational process in these artists' development.

9 DEVELOPMENT: HELPING IT ALONG

WHY DO MANY CHILDREN GIVE UP DRAWING AND PAINTING? WHAT CAN WE DO TO HELP?

Why do children give up painting and drawing when they draw with so much enthusiasm when they are very young? Genetic predispositions have strong effects but the environment, and especially the people in it, also contributes to either stunt drawing or help it to flourish. We have seen that much of children's drawing and painting is self-initiated. It is fortunate that children keep their representational programmes running even in the face of hostility. Trevarthen (1988) has said that even though language acquisition requires other people, it does have a 'temporary autonomy' which will serve it if for a little while if there is no support forthcoming from the environment. Derek Bickerton (1981) writes that language can be generated even if there is no adequate mother tongue available. He studied how Creole was created by babies whose mothers did not speak this language, but 'pidgin'. This strongly supports the theory that fundamentals of language acquisition are 'hard-wired', that is, the process of acquisition is initiated by programmes which are present in the central nervous system at, or near, birth. The same is probably true of drawing. However, for both language and drawing to fully develop, interaction from another language and drawing user is essential. Babies need an adult companion sharing in the representational adventure in which meanings are given to sounds, actions and images.

In this developmental landscape there are many crossroads at which children must choose a direction, and they sometimes get stuck in apparent impasses. They are not always able to tell you directly what they need but the clues about their thinking will be present in their action, play and media use. Using the patterns of development described in this book, it is possible for the caregiver to anticipate, and to a limited extent, predict, what the child might be moving towards. There are times when children might seem frustrated because they cannot find a way to represent their new understandings about the world. At such times, they may be actively searching the environment for help. Sometimes they are looking around in the culture for a particular type of image which will help them – in photographs and drawings; in books and comics; on TV and film. Children can learn about the drawing rules which translate a three-dimensional world onto a two-dimensional surface. This is why it is so wrong

to ban working from other people's pictures, as if these were 'second-hand' images. To think of this as mere 'copying' is to misunderstand this process altogether.

It is at such crossroads that 'more experienced learners' can be involved, making suggestions or putting certain experiences in children's paths. One example of this is when children become interested in rotating. In these instances, the caregiver might introduce a variety of interesting rotational experiences, from spinning tops to washing machines; and the nursery rhymes which are about rotating, like 'Ring o' Roses'.

Some people might think that children rotate because they hear these songs. Actually, it might be the other way around, it might be that children's schemas for rotation, both dynamic and configurative, cause them to choose these songs in preference to others. Hence these songs may have remained popular because of the demand created for them by children. I have used rotational songs as an example, but the same principle applies to other popular songs, rhymes, games and films, and computer and video games and this gives a good clue to possible teaching materials. 'Jack and Jill go up the Hill' and 'Humpty Dumpty' are good examples of ascent and descent, as is 'I'm the King of the Castle', which Ben liked at the time he was drawing the king and the castle. 'Tom and Jerry' cartoons are superb examples of trajectory and moment of impact and it is unfortunate that this kind of material is sometimes not available to children in the school context due to mistaken ideas about moral guidance. Similarly, it is sad that other trajectory-and-impact games of both boys and girls, including pretend shooting games, have been misconstrued as macho violence and banned from many nurseries.

At another level of development, when children start to use the oblique line to show depth, it might be relevant to discuss with them how these lines work, and to show them good examples of the use of oblique lines in other people's pictures. Most important of all, if we want children to continue to value art processes then we, as adults, have to genuinely enjoy them. Children will differentiate between sincere responses to their own work and insincere ones. It is a question of establishing an environment in which permission and trust are given to children to explore their own representational landscape. This is the kind of environment in which the different ways in which children and adults express themselves are respected; where children feel confident that people will take their drawings seriously, and where it would be unheard of for a child's drawing to be dismissed as mere scribbling.

It is never too early to discuss with children how their images work; it is just that one has to vary one's use of words according to the child's age. In

babyhood, it is a question of participating in that four-dimensional language of gesture, facial expression and sound in the shared space and time between baby and caregiver. The language of this ongoing conversation gradually takes different forms as the child grows. The number of words you say to children is not important. Some children need to be saturated in ideas but it is not always necessary, or advisable, to say anything at all. As Nancy Smith has said to me, sometimes one has to tip-toe unnoticed by a child who is drawing. Tina Bruce (1991) has also made the important point that when children show you a drawing they may just want to share this with you and may not expect any criticism at all.

The main point is that you try to understand what the child is trying to do. From playing and working with young children I have found that they are often surprised and delighted that adults have serious terms for the drawings they produce. When we talk to them about how lines, shapes and colours are working, we are helping their language and mathematical understanding. We are helping them to articulate and bring to consciousness important understandings about how representation works. In doing this, children gain more awareness of the limitations and possibilities of drawing processes, and start to realise that some, but not all, of their representational intentions communicate to other people, and they start to understand the reasons for this. One is expanding a shared field of discourse and understanding. They start to learn the terms too. I had a three year old running up to me exclaiming, 'Dr Matthews! Dr Matthews! I've drawn a closed-sheep!' (closed shape).

DID MY CHILDREN SEE ME PAINTING?

Most of the time, we protected Ben, Joel and Hannah from the worst excesses of my serious painting habit, but it is true that through the period of their childhoods, I was really involved in my painting, and I believe this affected them. I did allow them planned glimpses of some of my working procedures but only those approaches which might approximately fit in with some of the understandings they were forming in their own painting and drawings. I have a feeling that exposure to certain types of adult painting might not be so helpful to very young children. However, it just so happened that the kind of painting which interested me at the time was concerned with very basic relationships between movement and image and I think that this approximately matched the concerns of my children. In turn, my own painting and drawing was influenced by theirs, so it was hard to say who was influencing whom – it was a two-way process.

They saw that I was confident in my handling of art materials. All the things I used, they learnt to use. Photographic cameras, video-cameras; they grasped these literally and metaphorically. At around the age of nine, they were making some of my research recordings for me. Computers? The children introduced me to these!

SHOULD ONE PAINT OR DRAW FOR CHILDREN?

I did not draw for the nursery children. I did very occasionally draw for my own children, but usually in a minimal way, and based on what they could produce themselves. When I did draw for them, I explained as clearly as I could what I was doing. I explained that certain effects were the result of the drawing rules, and helped the children understand the structure and content of their drawings. I also made my sequence of drawing movements easy to follow.

However, after quarter of a century of being involved with young children, I would still advocate that one draws for children with extreme caution. Because the majority of people are speakers, they tend to converse, even with the babbler, in ways which are better than the ways in which they interact with the scribbler. It is important to stress that showing my drawing and working process to children were small elements in a larger approach to childcare. Responding to and talking about their own paintings and drawings had a far more significant effect on the children.

THE IMPORTANCE OF RECORD KEEPING

Keep a record of the paintings, drawings and constructions children make. The paintings and drawings themselves form a good record of development. Video recording is inexpensive and very useful, and the children can record their own work with help. Try to see the same or related themes in different media, and in their play and speech. Do not take the work away from children too soon. Let them see it on show for a long period of time, or help them to store it so that they see that they are building up a collection and that they can see their own progress. Ben, Joel and Hannah were given a variety of inexpensive drawing books of different sizes and quality which were always available for them to look through and return to (Whalley, 1994, also available in this series).

Do not restrict painting to easels but use tables and floor too. Painting at an easel is a valuable but often isolated activity. Working at an easel requires

particular skills. Standing and holding a brush against a near vertical surface can be exhausting. A group of tables placed together, with chairs around them means that children can talk to each other about their drawings, sit back and rest or view their own or others' work. Intriguing and important interaction often takes place when children are allowed to paint and draw in this way. Children are often good teachers and this sort of interaction provides different learning opportunities from the limited kind allowed by easel painting. However, each arrangement, whether easel, table-top, computer, is not simply 'good' or 'bad' but shapes the activity in certain ways. At an easel, for example, paint drips and runs which can be an advantage or disadvantage. Painting at an easel can involve one's whole body, which might not be the case when painting at a table or a computer.

Help children so that they can mix their own paints and display their own work. Of course, do not force anyone to paint or draw. If the ambience is right, the painting tables and easels will be inundated with customers. Nancy Smith has some good ideas about layout for painting for the very young (Smith, 1983). The main thing is to develop a sensitivity and a genuine interest in drawing itself; to its developmental patterns in childhood. Also, do not be rigid in your definitions; be open to the many forms of drawing. For example, does drawing necessarily have to leave a mark? Look at contemporary approaches to drawing (Rose, 1992). Some post-modern artists use movement as a form of drawing, and there is certainly a link between drawing and dance (Davies, in press).

PAINTING: THE UNFOLDING EVENT

I would like to finish this chapter with a final observation of Hannah, at two years and two months of age, painting alongside Linda. Hannah is at the phase of development in which she is starting to produce closed shapes and dots. The following observation is taken from a transcription of a video recording which, for analysis, was slowed down to quarter speed. I have chosen this example because it demonstrates all the main principles of interaction and provision we have considered throughout the book. These principles remain basically unchanged regardless of the age of the child.

Hannah is drawing with brush and paint. She is standing on a chair at a table on which rests an A1 size paper, some brushes and six pots of paint – black, red, yellow, purple, green and blue. Linda is seated at Hannah's left, within touching distance.

The sequence opens with Linda discreetly tucking Hannah's dress out of what she anticipates is Hannah's field of vision and movement. Hannah is attempting to lift a brush out of its pot. The brush is stuck and makes a squelching sound in the viscous paint. Linda's hands move in to assist, but it is only necessary for them to hover in readiness at the lip of the pot, for when Hannah lowers the red pot to the table the paint brush is dislodged.

Hannah presses the brush against the paper. Then she raises it fifteen centimetres and pauses for a fraction of a second. Whilst Linda's hands remain on the red pot to hold it steady, Hannah again presses the brush down vertically and firmly against the paper. She hunches her shoulders, putting weight and pressure upon the point of contact between bristles and paper. Linda is opening her mouth in interest and surprise and, with the merest movement of her eyes, looking up to Hannah's face and back down again to the painting, focusing on the events taking place where the brush hits the paper. As Hannah presses the brush down, she slightly screws up her eyes, and through compressed lips, emits a 'raspberry' sound which lasts less than a second and continues as the brush is raised about fifteen centimetres above the surface of the paper.

About fifteen seconds have elapsed as Hannah stabs the brush down vigorously to the same point, synchronising a raspberry sound to the moment of impact. As she raises the brush about fifteen centimetres above the surface she looks towards Linda, who returns her glance. This was impact number 3. Then she makes a series of rhythmical stabbing actions with each impact in one-to-one correspondence with a raspberry sound. She increases the volume of the synchronised raspberry sounds. As she raises the brush she gives an indrawn breath, like a little sigh.

During impact number 5 (again synchronised with a raspberry sound) which occurs at a site a few centimetres further away from her, Linda's open mouth transforms into a smile which develops as Hannah stubs the brush down for the sixth time.

After the eighth stab, she makes a longer pause, looking at Linda who smiles at her. Then Hannah immediately returns her gaze back to the painting. She then makes a series of vertical arcs with the brush, gradually quickening the tempo. At the start she holds her breath, but then gradually releases it in an audible sigh, breathing out as she increases the pace. She no longer synchronises vocals as she gradually rotates from the hips and shoulders making a series of spots in a wide arc around to her left and back again. This last impact is changed into a pull stroke which she visually tracks with an inclination of her head.

This seems to give her a new idea. She stops and pauses. She aims the brush

in the direction of the red pot but suddenly appears to reconsider this. She has changed her mind. She drops the brush and moves her left hand towards a lid. In slow motion, one can see her fingers splay out in anticipation of the circular shape. It is at this moment that Linda's hands move into assist, and in slow motion there occurs a beautiful ballet of interchanging hand movements between adult and child which centre around the paint pot. Linda 'scaffolds' the task (Gray, 1978, p. 169) but only to the extent that this enables Hannah to take the lead. Hannah presses down on the lid, but Linda discreetly completes the action of securing it on the top of the pot.

Hannah leans over to retrieve the blue pot with her right hand. Again her fingers splay out in anticipation of the form of the pot. She picks up the pot and successfully pulls off the lid with her left hand. Linda asks: 'What colour is that?' 'Bu', (blue) answers Hannah. As she puts down the blue pot near the centre of the paper, Linda reaches over the painting and removes the lid from Hannah's field of view and action. As soon as she has done this, she withdraws from the field of action and resumes her position at the side of the table.

Hannah is not aware of Linda's help for Linda seems to have timed this assistance to coincide with Hannah's preoccupation with her brush. In slow motion there is a beautiful ballet of hands and fingers as Hannah exchanges hand grips on the brush till she is satisfied that she has the best grip for her intended task. Her next actions are planned in advance. The dawning of this plan happened when she made the first trailing, rather than stabbing, motion of the brush. Now, she traces with the brush an anticlockwise course around the blue pot which serves as an axis. As she draws this line she visually tracks its movements with an absorbed expression. With her voice she starts to make a 'shhhhhhh'ing sound which is synchronised to the slow-moving brush as she drags it around the pot. She looks up at Linda for appreciation as she corrects the flight path of the skidding brush. It flies off the paper and swings back against the edge of the table with a loud bang. They both pause for a moment to regard this point.

Hannah looks towards Linda who returns her glance. Hannah makes one more downward stab which seems to serve as a full stop, or even an exclamation mark, for the entire sequence. Then she stands, open-mouthed, panning her head from side to side, surveying the entire scene. Then she looks up to me and compresses her lips in a slight smile. 'That's amazing Hannah,' I say.

There is pause of about two seconds, whilst the three of us look at the painting, a blue, curving line partially embracing clusters of red spots. Then Hannah looks for the lid of the blue pot. Linda helps her replace the lid. Hannah retrieves the red pot. A new painting sequence is about to begin.

ANALYSIS

A two year old starts and controls a painting as it develops

Careful analysis of the video recording shows Hannah coordinating skilled drawing actions. Hannah is initiating and controlling complex unfolding scenarios involving actions of the limbs, facial expression, speech, object manipulation, tool use and appearing image. It reveals Hannah's understandings of objects and forces; about the relations between her own actions and the images these produce. It shows how Hannah is noticing and using expressive qualities of movements and their images.

Interaction between adult and child

In addition, the sequence reveals the complex levels of interaction between Hannah and her mother. It shows how an adult can respond to and support children's early painting and it points the way to important general principles of interaction and provision. With Linda gently and sensitively supporting the lead taken by Hannah, they participate in a web of shared understandings and anticipations about what is unfolding on the paper's surface.

Inside the envelope of space between adult and child

A mark-making event like this is a development of those exquisitely orchestrated interchanges between mother and child which involve movements of the body, face and vocalisations (Stern, 1977; and Trevarthen, 1987). Here we see rhythmical patterns of movement of each partner coupled together precisely. This allows Hannah and Linda to enter into deep states of empathy with each other. Trevarthen has suggested that there is a biologically standardised time-base for these patterns of actions against which we evaluate the significance of any variation in tempo, amplitude, cadence, accentuation or stress. When Hannah makes controlled variations in this timing she does so to create expressive and humorous effects.

Mother and child as companions on an intellectual adventure

Both infant and mother are sharing a field of view which is also a field of action. This consists not only of the physical surface of the paper, the pots of paint and

brushes, but also a window opening onto a variety of potential but unknown futures. They are both predicting and anticipating events which may occur at the surface of the paper. They are stepping together into the unknown.

Both child and mother know something of each other's viewpoint. When either makes a movement, the viewpoint of the other is taken into consideration. Consider the kind and quality of the mother's support for her child's behaviour. It is notable that few words are spoken. Most of the communication between them consists of exchanged glances. There are different types of glance. Both parent and child seem able to distinguish effortlessly these. There is, for example, a questioning glance made by Hannah to which Linda frequently responds with an action instead of a word.

How Linda helps Hannah

There are many levels of teaching here, ranging from one of simple instruction (as when Linda asks, 'What colour is that?' and Hannah answers, 'Bu'); to one of demonstration, and to much more subtle communications and shared understandings. The mother, mainly by her body language, gives a 'commentary' on the event (Harris, 1989, p. 22). Much recent curriculum design in Britain and elsewhere only acknowledges the instructional level, which is the least important level. We need more studies about the interpersonal gestural and expressive language formed between adult and child, for it is part of the principles of teaching interaction.

Linda is aware of Hannah's field of view and movement, entering this space only when absolutely necessary and in an unobtrusive way, her actions of management timed to coincide with Hannah's preoccupation with a brush or a pot. Linda withdraws from this space quickly, allowing Hannah to resume command of the movement. Linda only helps when a task (such as taking a lid from a pot) might interrupt the flow of Hannah's thinking, and then she moves her hands in a clear, defined way, respecting Hannah's field of view. In this way, the child is allowed to see what is happening and is able to take control again. At times, this scaffolding allows Hannah the illusion of complete mastery and control.

Drawing is not a problem-solving situation

Both mother's and child's responses to unforeseen events are illuminating. Neither are upset by the brush flying away from the paper and banging the side

of the table, rather, they regard this event with the greatest interest. Some researchers habitually regard drawing as a problem-solving situation – this is incorrect and misleading. There are no problems here. There is an interplay between the child's intentions and the chance occurrences which affect these. Whilst Hannah continuously monitors and corrects the flight of the brush, she does so without a fixed goal in mind, but tolerates a wide range of variation from her initial plans. This is unlike the High/Scope method of early childhood education (1979) in which nursery age children are expected to plan in advance what they intend to do with play materials. This runs counter to everything we understand about child development for it requires very young children to think at an abstract level before they have had the experiences of dynamic play and exploration from which abstract thinking grows.

Hannah takes advantage of accidents, but not merely at the level of spotting chance resemblances, rather, a small sequence of movement (as when a stabbing motion is changed to a trailing one) suggest to her possibilities of new sequences of action.

Hannah makes the decisions

Linda's response to the fluid variety of this painting event is crucial. At no time has the child been given any sense that she is 'misbehaving'. Linda does not impose any preconceptions of her own, or put limitations on what happens. Hannah herself is allowed to define the painting experience.

Red raspberries; blue trails

Of great significance is Hannah's use of distinctly different types of vocalisation to accompany equally distinct types of marking action and mark. Discontinuous, loud 'raspberries' are synchronised with vertical impacts and red blobs; quiet, continuous 'shhh's to accompany a continuous, slowly moving blue line.

In this and other examples, she is exploring different types of *equivalence*, (Arnheim, 1954, 1974; and Matthews, 1990) which are emerging from the same event. At one level of description, we can see this as the beginning of counting. She is counting her own movements and marks and this will eventually lead to her use of the abstract numbering system. Another path of development is branching out from this episode which is based on her awareness that her movements and marks share characteristics with other objects and events.

A two year old has ideas about painting

This is the beginning of those associations between sound, movement and image we saw in earlier observations. She may have felt there was similarity between the sound of 'raspberries' and the sound and tactile sensations of brush in squelchy paint; and between a soft 'shhh' and the sound of trailing bristles. She is exploring the idea that one action or image can echo, represent or be equivalent to, another action or image. This is the basis for visual representation and expression. She is manipulating and playing not with objects alone, but with ideas.

DIFFERENT KINDS OF REALISM

Although it is clear that Hannah is very pleased with her painting, some people say that she will soon want to paint 'realistic' pictures and this is where development is taking her. But what is 'realistic' to a child changes with age and context. At various points in their lives children resist so-called advanced systems because, far from making pictures more 'realistic' for them, these systems actually sacrifice understandings about their worlds which they feel important. For example, a table drawn in perspective loses its right-angular corners, and its rectangular shape is distorted. This may be part of the reason why, when children become interested in Euclidean or rigid geometry, they make drawings which preserve the structure of 'carpentered' objects.

DRAWING AS AN INTERPLAY OF FORCES RATHER THAN THE REPRESENTATION OF OBJECTS

When obvious changes do occur in the way children represent the world, this partly reflects changes in their priorities about the type of information they feel it is essential to capture (Light, 1985). Children are harmed when they are forced to abandon these forms of expression and representation and are trained prematurely in narrow versions of drawing. The idea that the representation of objects is at the heart of drawing is completely wrong. As Arnheim has written, drawing is primarily an interplay of different forces (Arnheim, 1954; 1974).

It is helpful to study the different systems which artists have used in different places around the world and at different times. The Chinese, for example, were acquainted with the depiction of three-dimensional form as early as the seventh

century but chose not to use it because they thought it was unsuitable for the aims of their painting. They were not thinking of the painting as a 'window' opening out onto a physical world but were trying to achieve a transcendental space (Sullivan, 1973; Edgerton, 1980). Indian painting often uses the vertical oblique projection system, in which we see plan views of, for example, carpets, simultaneously with side elevations of people and other objects. Vertical oblique and other systems are combined in Cubist painting (Willats, 1983) and some post-modern art uses a multiplicity of symbol and signs, some of which are not linked to the visible world at all. It is a tragic irony that teachers who profess to be 'multicultural' and 'antiracist', whilst deifying art works from other cultures reveal their total lack of understanding by condemning the exact same systems as used by their pupils.

Although adult artists are different from children in that they have greater control over a range of representational systems, nevertheless young children also choose from a range of options available. As Hannah grows, she does not merely abandon these in favour of more advanced ones, rather they become re-worked at new levels, transformed by revolutions in her thinking and integrated in more complex systems (Athey, 1990; and Wolf, 1989). As we have seen in the example of Ben, even perspective drawing, if understood properly, incorporates those early understandings about time, space and movement formed in infancy.

SUMMARY

In this book I have described the origin and development of children's use and organisation of visual media. I have argued that this is a continuum which exhibits semantic and organisational characteristics at every level; that is, it has structure and meaning all the way through. This is true of the outset of representation, during the period when, according to popular wisdom and to any number of other accounts, children are supposed to be mindlessly 'scribbling'. The fact that, in this book, the beginning of representation is so fundamentally different from other accounts has implications for the way we understand and provide for later education – and not just art education.

I have argued that drawing and painting can play a central role in the development of cognition and affect. When children draw and paint they move through an important sequence of thinking and feeling. We have seen that there is an important mathematical aspect and that language is involved. Drawing and painting extend language, *if* adults talk intelligently with children about

their drawings and paintings. Language organises drawing, and it might be that all representation owes much to the syntax of language.

In fact, I have suggested that drawing and painting are part of an entire family of expressive and representational ways or 'modes' generated in infancy which are integrated together to help the child form descriptions of their worlds.

We have seen that as children grow older, their drawing changes. This is due to changes in their priorities about essential information to be encoded in a drawing (Light, 1985). These changes may be prompted by revolutions occurring periodically in the child's thinking. When children struggle to show more of the truth about their worlds, they produce drawings which may look strange to some adults. However, it is a mistake to measure these against a limited notion of visual realism and evaluate them in terms of supposed deficits. Their drawings are frequently the result of combinations of different types of knowledge encoded in different systems. It is our responsibility to decode these systems in order to help children understand how their lives and their worlds are represented within them. The better we understand our representations of the world, the better we will be able to cope with our own futures.

BIBLIOGRAPHY

Ahlberg, J. and A. (1981) *Peepo!* Kestrel Books.

Arnheim, R. (1954, 2nd edn 1974) *Art and Visual Perception: A Psychology of the Creative Eye.* Berkely: University of California Press.

Athey, C. (1977) 'Humour in children related to Piaget's theory of intellectual development', in Chapman, A.J. and Foot, H.C. (eds) *It's a Funny Thing, Humour.* Oxford: Pergamon Press.

Athey, C. (1990) *Extending Thought in Young Children: A Parent Teacher Partnership.* London: Paul Chapman.

Bartholomew, L. and Bruce, T. (1993) *Getting to Know You: A guide to record keeping in early childhood education and care.* London: Hodder & Stoughton.

Bates, E. (1976) *Language in Context.* New York: Academic Press.

Berefelt, G. (1987) 'Sex differences in scribbles of toddlers: graphic activity of 18 month old children', *Scandinavian Journal of Educational Research,* **31**, 23–30.

Bickerton, D. (1981) *The Roots of Language.* Ann Arbor: Karoma Publishing.

Borke, H. (1983) 'Piaget's mountains revisited: changes in the egocentric landscape', in Donaldson, M., Grieve, R. and Pratt, C. (eds) *Early Childhood Development and Education* (pp. 254–9). Oxford: Basil Blackwell.

Bower, T. (1974, 1982) *Development in Infancy.* San Francisco: Freeman.

Bremner, J.G. (1985) 'Figural biases and young children's drawings', in Freeman, N.H. and Cox, M.V. (eds) *Visual Order: The Nature and Development of Pictorial Representation* (pp. 301–31). Cambridge: Cambridge University Press.

Bretherton, I. (1984) *Symbolic Play.* London: Academic Press.

Bruce, T. (1987) *Early Childhood Education.* London: Hodder & Stoughton.

Bruce, T. (1991) *Time to Play in Early Childhood Education.* London: Hodder & Stoughton.

Bruner, J.S. (1964) 'The course of cognitive growth', *American Psychologist,* **19**, 1–15, reprinted in Kintz, B.L. and Brunig, J.L. (eds) (1970) *Research in Psychology,* pp. 289–96. Scott Foresman and Co.

Bruner, J.S. (1990) Paper presented at IVth European Conference on Developmental Psychology. Scotland: University of Stirling.

Chomsky, N. (1966) *Cartesian Linguistics.* New York: Harper and Row.

Condon, W. (1975) 'Speech makes babies move', in Lewin, R. (ed.) *Child Alive.* London: Temple Smith.

Connolly, K. (1975) 'The growth of skill', in Lewin, R. (ed.) *Child Alive.* London: Temple Smith, pp. 137–48.

Costall, A. (1992) 'Seeing versus knowing: space versus time. Presentation for Workshop *Drawing Events.* Southampton: Department of Psychology, University of Southampton.

Court, E. (1987) 'Drawing on culture: some views from rural Kenya'. A paper presented at a symposium on Social and Cultural Influences on Children's Drawings, Biennial Meeting of the Society for Research in Child Development, Baltimore, Maryland, 24 April 1987. Elsbeth Court, Institute of Education, University of London.

Cox, M. (1992) *Children's Drawings*. Harmondsworth: Penguin.

Davies, M. (1969) 'Movement: Action, feeling and thought' in Brearley, M. (ed.) *Fundamentals in the First School*. Oxford: Basil Blackwell.

Davies, M. (in press 1994) *Moving to Learn*. London: Hodder & Stoughton.

de Villiers, P.A. and de Villiers, J.G. (1979) *Early Language*. London: Fontana.

Donaldson, M. (1978) *Children's Minds*. Glasgow: Fontana.

Edgerton, S.Y. (1980) 'The Renaissance artist as quantifier', in Hagen, M.A. (ed.) *The Perception of Pictures*, Vol. 1, Alberti's Window, pp. 179–212. New York: Academic Press.

Fenson, L. (1985) 'The transition from construction to sketching in children's drawing', in Freeman, N.H. and Cox, M.V., *Visual Order: The Nature and Development of Pictorial Representation*, pp. 374–84. Cambridge.

Ferreiro, E. and Teberosky, A. (1982) *Literacy Before Schooling*. Oxford: Heinemann Educational.

Freeman, N.H. (1972) 'Process and product in children's drawing', *Perception*, **1**, 123–40.

Freeman, N.H. (1980) *Strategies of Representation in Young Children*. London: Academic Press.

Freeman, N.H. and Cox, M.V. (1985) (eds) *Visual Order: The Nature and Development of Pictorial Representation*. Cambridge: Cambridge University Press.

Fucigna, C. (1983) Research Proposal: M.A. Thesis. Tufts University, Mass. 02155, USA.

Furth, H.G. (1969) *Piaget and Knowledge*. New Jersey: Prentice-Hall.

Gelman, R. and Gallistel, C.R. (1983) 'The child's understanding of number', in Donaldson, M.; Grieve, R. and Pratt, C. (eds) *Early Childhood Development and Education*, pp. 185–203. Oxford: Basil Blackwell.

Gibson, J. (1966) *The Senses Considered as Perceptual Systems*. Boston: Houghton Mifflin.

Gibson, J.J. and Yonas, P. (1968) 'A new theory of scribbling and drawing in children', in Levin, H.; Gibson, E.J. and Gibson, J.J. (eds) *The Analysis of Reading Skills*. US Dept of Health, Education and Welfare, Office of Education, Washington DC.

Golomb, C. (1974) *Young Children's Sculpture and Drawing*. Cambridge, Mass: Harvard University Press.

Golomb, C. (1992) *The Child's Creation of a Pictorial World*. University of California Press.

Goodnow, J. (1977) *Children's Drawing*. Cambridge, Mass: Harvard University Press.

Gray, H. (1978) 'Learning to take an object from the mother', in Lock, A. (ed.) *Action, Gesture and Symbol: The Emergence of Language*, pp. 159–83. London: Academic Press.

Gura, P. (ed.) (1992) *Exploring Learning: Young Children and Blockplay*. London: Paul Chapman.

Harris, P. (1989) *Children and Emotion*. Oxford: Basil Blackwell.

Hohmann, M., Banet, B. and Weikart D.P. (1979) *Young Children in Action*. Michigan: High/Scope Press.

Kelly, A.V. (1990) *The National Curriculum: A Critical Review*. London: Paul Chapman.

Kellogg, R. (1969) *Analyzing Children's Art*. Palo Alto, California: National Press Books.

Light, P. (1985) 'The development of view-specific representation considered from a socio-cognitive standpoint', in Freeman, N.H. and Cox, M.V. (eds) *Visual Order: The Nature and Development of Pictorial Representation*, pp. 214–29. Cambridge: Cambridge University Press.

Lowenfeld, V. and Brittain, W.L. (1970) *Creative and Mental Growth*. New York: Macmillan.

Luquet, G.H. (1927) *Le Dessin Enfantin*. Paris: Alcan.

Marr, D. (1982) *Vision: A Computational Investigation into Human Representation and Processing of Visual Information*. San Francisco: Freeman.

Matthews, J. (1983) 'Children drawing: are young children really scribbling?' Paper presented at British Psychological Society's International Conference on 'Psychology and the Arts', University of Cardiff.

Matthews, J. (1984) 'Children drawing: are young children really scribbling?' *Early Child Development and Care*, **18**, pp. 1–39, Gordon and Breach.

Matthews, J. (1986) 'Children's early representation: the construction of meaning', *Inscape: Journal of British Association of Art Therapists*. Winter vol., 12–17.

Matthews, J. (1988) 'The young child's early representation and drawing', in Blenkin, G.M. and Kelly, A.V. (eds) *Early Childhood Education: A Developmental Curriculum*, pp. 162–83. London: Paul Chapman.

Matthews, J. (1989) 'How young children give meaning to drawing', in Gilroy, A. and Dalley, T. (eds) *Pictures at an Exhibition: Selected Essays in Art and Art Therapy*, pp. 127–42. London and New York: Tavistock/Routledge.

Matthews, J. (1990) 'Expression, Representation and Drawing in Early Childhood', Unpublished PhD Thesis, University of London.

Matthews, J. (1992) 'The genesis of aesthetic sensibility', in Thistlewood, D. (ed.) *Drawing, Research and Development*, pp. 26–39. Essex: NSEAD and Longman.

Matthews, J. (1993) 'Art in the National Curriculum: implications for early childhood education and care', *Nursery World*, 8 April 1993, 18–20, London.

Matthews, J. and Jessel, J. (1993a) 'Very young children and electronic paint: the beginnings of drawing with traditional media and computer paintbox', *Early Years*, Spring, **13**, 2, pp. 15–22, London.

Matthews, J. and Jessel, J. (1993b) 'Very young children use electronic paint: a study of the beginnings of drawing with traditional media and computer paintbox' (original version), *Visual Arts Research*, Spring, **19**, 1, Issue 37, pp. 47–62, University of Illinois; USA.

Michotte, A. (1963) *The Perception of Causality*, Methuen Manual of Modern Psychology. London: Methuen.

Mounoud, P. and Hauert, C.A. (1982) 'Development of sensorimotor organisation in young children: grasping and lifting objects', in Forman, G.E. (ed.) *Action and Thought: From*

Sensorimotor Schemes to Symbolic Operations, pp. 3–35. New York: Academic Press.

Opie, I. and Opie, P. (1959) *The Lore and Language of School Children*. London: Oxford University Press.

Partington, J.T. and Grant, C. (1984) 'Imaginary playmates and other useful fantasies', in Smith, P.K. (ed.) *Play in Animals and Humans*, pp. 217–40. Oxford: Basil Blackwell.

Petitto, L. (1987) 'Gestures and Language in Apes and Children'. A talk given at the Medical Research Council's Cognitive Development Unit, London, 28 May.

Piaget, J. (1951) *Play, Dreams and Imitation in Childhood*. London: Routledge and Kegan Paul.

Piaget, J. and Inhelder, B. (1956) *The Child's Conception of Space*. London: Routledge and Kegan Paul.

Reddy, V. (1991) 'Playing with others' expectations: teasing and mucking about in the first year' in Whiten, A. (ed.) *Natural Theories of Mind*, pp. 143–58. London: Blackwell.

Richards, M. (1980) *Infancy: World of the Newborn*. London: Harper and Row.

Rose, B. (1992) *Allegories of Modernism: Contemporary Drawing*. New York: Museum of Modern Art.

Selfe, L. (1977) *Nadia: A Case of Extraordinary Drawing Ability in an Autistic Child*. London: Academic Press.

Smith, N.R. (1972) 'Developmental origins of graphic symbolization in the paintings of children 3–5', Harvard University, D.A.I. order no. 7909892.

Smith, N. (1979) 'Developmental origins of structural variations in symbol form', in Smith, N.R. and Franklin, M.B. (eds) *Symbolic Functioning in Childhood*, pp. 11–26, New Jersey: Erlbaum, Hillsdale.

Smith, N.R. (1983) *Experience and Art: Teaching Children to Paint*. Teacher's College Press, Columbia University.

Spelke, E. (1985) 'Perception of unity, persistence and identity: thoughts on infants' conceptions of objects', in Mehler, J. and Fox, R. (eds) *Neonate Cognition: Beyond the Blooming, Buzzing Confusion*, pp. 98–113. New Jersey: Erlbaum.

Stern, D. (1977) *The First Relationship: Infant and Mother*. Glasgow: Fontana.

Sullivan, M. (1973) *The Meeting of Eastern and Western Art from 16th Century to Present Day*. London: Thames and Hudson.

Tarr, P. (1990) More than movement: scribbling reassessed, *Visual Arts Research*, Vol. 16, no. 1, Issue 31, pp. 83–89.

Temple A.T., Nathan, R.G. and Burris, N.A. (1982) *The Beginnings of Writing*. Boston, USA: Allyn and Bacon.

Thomas, G. and Silk, A.M.J. (1990) *An Introduction to the Psychology of Children's Drawings*. New York: Harvester Wheatsheaf.

Trevarthen, C. (1975) 'Early attempts at speech', in Lewin, R. (ed.) *Child Alive*, pp. 62–80. London: Temple Smith.

Trevarthen, C. (1980) 'The foundations of intersubjectivity: the development of interpersonal

and cooperative understanding in infants', in Olson, D. (ed.) *The Social Foundations of Language and Thought: Essays in Honour of J.S. Bruner*, pp. 316–42. New York: W.W. Norton.

Trevarthen, C. (1984) 'How control of movement develops', in Whiting, H.T.A. (ed.) *Human Motor Actions – Bernstein Reassessed*, pp. 223–59. Amsterdam: Elsevier Science Publishers.

Trevarthen, C. (1987) 'Motives for culture in young children: their natural development through communication'. A paper presented at the International Symposium on the Nature of Culture, Ruhr-Universitat Bochum, September 1987.

Trevarthen, C. (1988) 'Human communication is emotional as well as cognitive – from the start'. A talk given at the Medical Research Council's Cognitive Development Unit, Euston, London, 23 June 1988.

Trevarthen, C. and Grant, F. (1979) 'Infant play and the creation of culture', *New Scientist*, February 566–9.

Trevarthen, C. and Hubley P. (1978) 'Secondary intersubjectivity: confidence, confiding and acts of meaning in the first year,' in Locke, A. (ed.) *Action, Gesture and Symbol: The Emergence of Language*, pp. 183–229. London: Academic Press.

Van Sommers, P. (1984) *Drawing and Cognition: Descriptive and Experimental Studies of Graphic Production Processes*. Cambridge: Cambridge University Press.

Von Hofsten, C. (1983) 'Catching skills in infancy', *Journal of Experimental Psychology: Human Perception and Performance*, **9**, 75–85.

Vygotsky, L. (1986) *Thought and Language*. Cambridge, Massachusetts: M.I.T. Press.

Whalley, M. (1994) *Learning to be Strong: setting up a neighbourhood service for under-fives and their families*. London: Hodder and Stoughton.

White, B.L., Castle, P. and Held, R. (1964) Observations on the development of visually directed reaching, *Child Development*, **35**, 349–64.

Whitehead, M. (1990) *Early Literacy*. London: Paul Chapman.

Willats, J. (1983) 'Unusual pictures: an analysis of some abnormal pictorial structures in a painting by Juan Gris', *Leonardo*, **16**, 3, 188–92.

Willats, J. (1984) 'Getting the drawing to look right as well as be right: the interaction between production and perception as a mechanism of development', in Crozier, W.R. and Chapman, A.J. (eds) *Cognitive Processes in the Perception of Art*, 111–25, Amsterdam.

Willats, J. (1985) 'Drawing systems revisited: the role of denotational systems used in children's figure drawings', in Freeman, N.H. and Cox, M.V. (eds) *Visual Order: The Nature and Development of Pictorial Representation*, 78–100. Cambridge: Cambridge University Press.

Willats, J. (1992) 'The representation of extendedness in children's drawings of sticks and discs', in *Child Development*, **63**, 692–710.

Winner, E. (1989) 'How can Chinese children draw so well?' *Journal of Aesthetic Education*, **22**, 17–34.

Winnicott, D.W. (1971) *Playing and Reality*. London: Tavistock.

Wittgenstein, L. (1973) *Philosophical Investigations*, translated by G.E.M. Anscombe. New York: Macmillan.

Wolf, D. (1983) 'The origins of distinct symbolic domains: the waves of early symbolization. The example of event structuring'. Paper presented at the Annual Meeting of the Eastern Psychological Association, Philadelphia, April 1983, Harvard Project Zero, Longfellow Hall, HGSE Cambridge, MA 02138.

Wolf, D. (1984) 'Repertoire, style and format: notions worth borrowing from children's play', in Smith, P.K. (ed.) *Play in Animals and Humans*. Oxford: Basil Blackwell.

Wolf, D. (1989) 'Artistic learning as a conversation', in Hargreaves, D. (ed.) *Children and the Arts* (pp. 23–39). Open University Press: Milton Keynes.

Wolf, D. and Fucigna, C. (1983) 'Representation before picturing', Transcript of paper presented at the Symposium on Drawing Development, British Psychological Society International Conference on Psychology and the Arts, University of Cardiff, Wales.

Wolf, D. and Perry, M.D. (1988) 'From endpoints to repertoires: some new conclusions about drawing development', in *Journal of Aesthetic Education*, **2**, 1, Spring, 17–34.

Wolf, D., Rygh, J. and Altshuther, J. (1984) 'Actions and states in play narratives', in Bretherton, I. (ed.) *Symbolic Play* (pp. 195–217). London: Academic Press.

Zhensun, Z. and Low, A. (1991) *A Young Painter: The Life and Paintings of Wang Yani – China's extraordinary young artist*. New York: Scholastic Inc.

Index